COVER *The Concert*, detail (no. 11)

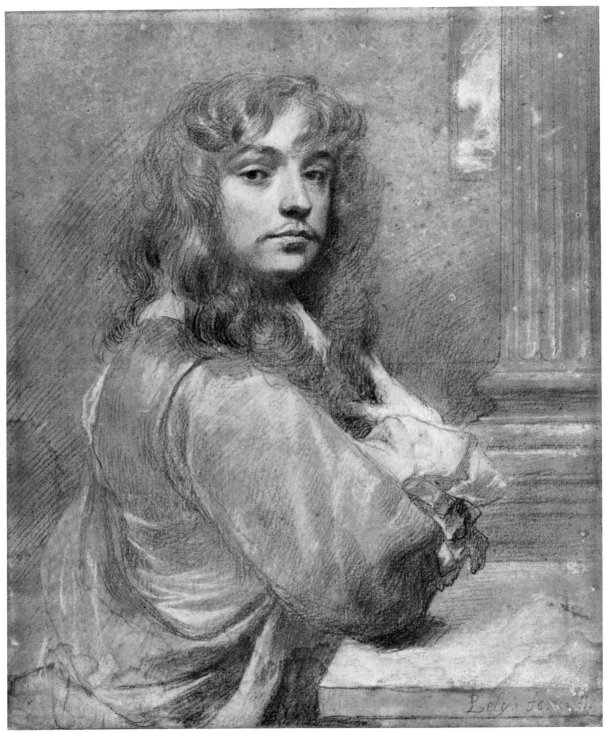

Sir Peter Lely, self-portrait (no. 70)

Oliver Millar

Sir Peter Lely

1618–80

exhibition at 15 Carlton House Terrace, London SW1

National Portrait Gallery

Contents

Foreword 5

List of lenders 6

Acknowledgements 7

Introduction 9

Bibliographical note 32

Catalogue notes 33

Catalogue

Paintings 34

Drawings 73

Index 88

Published for the exhibition held from
17 November 1978 to 18 March 1979 at the
National Portrait Gallery Exhibition Rooms,
15 Carlton House Terrace, London SW1

Exhibition Organiser Malcolm Rogers
Exhibition Designer Joe Pradera

ISBN 0 904017 25 7
Published by the National Portrait Gallery,
London WC2H 0HE

Catalogue edited by Mary Pettman
Designed by Graham Johnson/Lund Humphries
Printed in England by Lund Humphries,
London and Bradford

Foreword

Three foreign portrait painters dominated English painting during the seventeenth century: Van Dyck, Lely and Kneller. All three were knighted for their services to the court, which remained the centre of artistic patronage throughout the period. Van Dyck has frequently been studied and assessed; Kneller was the subject of a National Portrait Gallery exhibition in 1971. Lely, on the other hand, has received much less critical attention, and no exhibition devoted solely to his work has previously been held. There are reasons for this disenchantment. Pepys voiced an element of contemporary dissatisfaction when he said of one portrait: 'good, but not like', and Lely's reputation has suffered from his own industriousness, the stereotyped designs from which his sitters were asked to select, the many versions and copies which emanated from his efficiently-run studio, and the licentiousness of the fashionable society he portrayed. It may come as a surprise, therefore, to discover Lely's true qualities: the delicacy of handling in his earlier work, the continual beauty of his use of paint, the range, the vigour and the confidence of his later compositions, the assurance of his draughtsmanship.

For this unique opportunity to see Lely at his finest we are indebted to Sir Oliver Millar, Surveyor of the Queen's Pictures, a Trustee of the Gallery, and the foremost authority on painting in Britain in the seventeenth century. No one could have selected the exhibits to greater purpose. But Sir Oliver has not only chosen and catalogued the exhibition; he has also given us, in the pages which follow, what is virtually a monograph on Lely. His fellow Trustees and I are deeply grateful for the skills and learning which have been so freely at the Gallery's disposal. Thanks are also due to Joe Pradera, who has designed a setting for the exhibition which brilliantly yet economically evokes the interiors of Lely's day. However, our greatest debt, as always, is to the many owners who have so generously agreed to lend their treasures. Her Majesty The Queen has graciously lent three works from the Royal Collection, and the response to our requests for loans has been wholehearted; thus, for example, we have been privileged to be able to assemble all but two of Lely's drawings for his procession of Knights of the Garter. We hope that the resulting exhibition will give pleasure to a wide public.

JOHN HAYES
Director, National Portrait Gallery
July 1978

List of lenders

Her Majesty The Queen 38, 79, 80

Graphische Sammlung Albertina, Vienna 103

The Visitors of the Ashmolean Museum, Oxford 65, 78, 114

The Trustee of the Will of the 8th Earl of Berkeley (deceased) 16

Birmingham City Museums and Art Gallery 22, 61

The Curators of the Bodleian Library, Oxford 2

The Executor of the late Denys Eyre Bower 44

Boymans-van Beuningen Museum, Rotterdam 64

The Rt Hon the Earl of Bradford 58

The Trustees of the British Museum 75–77, 82–85, 87–96, 108, 111, 112, 115, 116

BSR Ltd 46

The Administrative Trustees of the Chequers Trust 26

The Administrative Trustees of the Chevening Estate 34

The Earl of Clarendon 39

The Rt Hon Lord Clifford of Chudleigh, OBE, DL 42

Courtauld Institute of Art: Lee Collection 11

Courtauld Institute of Art: Witt Collection 66–68, 102, 113

E. B. Crocker Art Gallery, Sacramento, California 97

Viscount De L'Isle, VC, KG 19

The Devonshire Collection, Chatsworth: The Trustees of the Chatsworth Settlement 5, 20, 106

The Rt Hon Lord Dulverton, CBE, TD, MA 24

The Governors of Dulwich College Picture Gallery 25, 28

The Syndics of the Fitzwilliam Museum, Cambridge 72

Fogg Art Museum, Harvard University, Cambridge, Massachusetts 86

Fondation Custodia (Coll F. Lugt), Institut Néerlandais, Paris 62, 109

The J. Paul Getty Museum 49

The Duke of Grafton 43, 52

The Earl of Jersey 71

Kimbell Art Museum, Fort Worth, Texas 18

The Directors of Lamport Hall Preservation Trust Ltd 56

Dr D. McDonald 12–14

The Hon Dr Anne McLaren 3

City of Manchester Art Galleries 30

Metropolitan Museum of Art, New York 27

National Gallery of Canada, Ottawa 10

National Maritime Museum, Greenwich 17, 40, 48

National Portrait Gallery, London 29, 41

The Hon R. H. C. Neville 51

The Trustees of the Newdegate Settlement 55

His Grace the Duke of Norfolk, CB, CBE, MC 53, 54

Roger North, Esq 59

His Grace the Duke of Northumberland, KG, PC, TD, FRS 6, 8

Pierpont Morgan Library, New York 74A

Private collections 1, 4, 31, 36, 50, 60, 69, 70, 73, 81, 99, 110

Rijksmuseum, Amsterdam 74, 100, 107

Rugby School 63

The Trustees of the Earl of Sandwich's 1943 Settlement 35

Scottish National Portrait Gallery 32, 33, 37

Earl Spencer 45

The Rt Hon Lord Tollemache 15

HM Treasury and the National Trust (Egremont Collection, Petworth) 7

Collection V. de S., Netherlands 105

Victoria and Albert Museum 21, 23, 101

The Executors of the 4th Duke of Westminster (deceased) 57

The Earl of Yarborough 9

York City Art Gallery 47

Acknowledgements

I am grateful to Dr John Hayes, Director of the National Portrait Gallery, for the invitation to organise this exhibition. Sir Peter Lely has never been so honoured before, but he occupied such a prominent position in the artistic life of this country in his own day, and played so important a part in the development of the English portrait, that no excuse is needed for this attempt to illustrate and evaluate his achievement.

The ideal Lely exhibition would include examples of the work of his predecessors, successors and contemporaries, and illustrate the workings of the studio and the dissemination of his most popular portraits by engravings; but we have concentrated, for reasons of space, on assembling a series of works which demonstrate Lely's development as a painter, and we have tried to choose works of the finest quality so that the measure of his abilities as an artist can be taken. Only one or two examples have been chosen to illustrate the part played in the completion of a portrait by assistants in the studio.

For a Trustee of the National Portrait Gallery, it has been an unusual privilege to work with members of the staff of the Gallery. I am grateful to Miss Jacquie Meredith and Miss Mary Pettman for their work, respectively, in assembling the pictures and drawings and for seeing the catalogue through the press. It has been a special pleasure to work on the exhibition with Dr Malcolm Rogers and to discuss with him the selection of exhibits and many other points. I am equally grateful to Mr Joe Pradera, the designer of the exhibition, Mr Graham Johnson of Lund Humphries, who designed the catalogue, and Mrs Gilbert Cousland, who prepared my manuscript.

I have incurred many debts in compiling the catalogue: Dr Charles Avery discussed with me sculpture which appears in Lely's designs; Dr Anthony Baines gave advice on musical instruments; Miss Diana de Marly placed at my disposal her knowledge of the fashions in dress which Lely's sitters follow; and Sir Anthony Wagner set the Garter procession in its proper order, and suggested identifications for some of the participants. Professor Peter Murray, Mr Richard Ollard, Mr Maurice Tomlin and Mr Philip Troutman answered a variety of questions. Dr J. A. van Alphen and Dr R. P. Meijer helped me to read obscure passages in Dutch texts. I am particularly grateful to Mr. M. Kirby Talley for placing at my disposal his notes on Lely's technical methods, drawn chiefly from the Executors' Accounts. Miss Gillian Lewis has carried out detailed examinations of the pictures lent by the National Maritime Museum and the Dulwich College Picture Gallery; I have had very profitable discussions with Miss Lewis and with Mr W. W. Percival-Prescott on Lely's technique; and Miss Lewis has provided the revealing X-ray photograph (fig. 14; p. 59) of Captain Harman. Mr Michael Warnes gave valuable help over Lely's drawings.

My chief debt, however, must be to the owners of Lely's works who over many years have allowed me access to them.

O.N.M.
July 1978

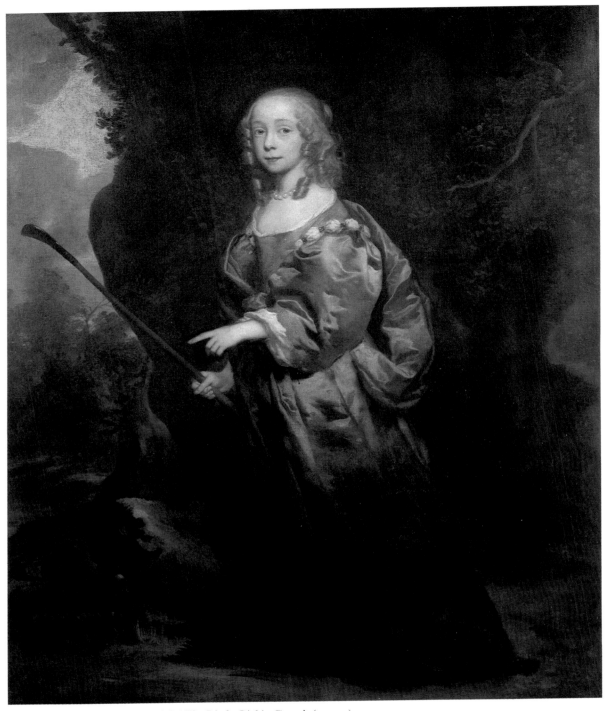

Colour plate I *Portrait of a Girl: 'The Little Girl in Green'* (no. 20)

Introduction

Early years

'Pieter van der Faes, otherwise known as Lely' was born in the garrison town of Soest in Westphalia on 14 September 1618. His mother, Abigail van Vliet, came of a distinguished Utrecht family; his father, Johan van der Faes, was captain of a company of infantry in a Dutch regiment in the service of the Elector of Brandenburg, stationed in Westphalia at the time of Lely's birth. His father had been born in a house in The Hague with a lily carved on the gable. As early as 1562 Heyndrick Cornelisz. Faes, a bricklayer and probably the painter's great-grandfather, had bought a house *in de Lelye* on the western side of the Noordeinde of The Hague. In 1625 the house was occupied by Claes Heyndricksz. Faes, a shoemaker and firewarden, who was then sixty-seven years old and presumably father of the captain. The Van der Faes family, which may have come originally from Antwerp, were by now people of substance who owned houses in the fashionable quarter of The Hague.[1]

Pieter van der Faes must have been brought up in the rough soldiers' world so vividly brought to life in countless Dutch prints and paintings. At an early age he took on his famous nickname. As Pieter Lely he appears in a short list, in the minutes of the Guild of St Luke in Haarlem for October–November 1637, of the pupils of Frans Pieters de Grebber who at that date had not been officially registered.[2]

The Civil War and Commonwealth

The date of Lely's arrival in England has not yet been established. Richard Graham, who composed the earliest printed account of Lely's career,[3] states that he came to England in 1641. In the first formal short biographies to be published in Holland,[4] he is said to have spent two years with De Grebber and to have come to London in 1643. In these accounts his journey is associated with the visit of Prince William II of Orange on the occasion of his marriage to the Princess Royal, eldest daughter of Charles I, which had in fact taken place in the spring of 1641. Attempts to link him with the portrait of the bridal pair by Van Dyck have not been convincing; and there is no evidence that Lely saw Charles I before the outbreak of the Civil War.

There is no reason to doubt Graham's statement that on his arrival Lely 'pursu'd the natural bent of his *Genius* in *Landtschapes* with *small Figures*, and Historical *Compositions:* but finding the practice of *Painting after the Life* generally more encourag'd, he apply'd himself to *Portraits* . . .' Two landscape drawings (nos. 60 and 61) which are almost certainly correctly ascribed to him are Dutch in style; and among the comparatively small number of his '*Landtschapes* with *small Figures*' to survive are some awkwardly composed pictures which are his earliest surviving works. Unfortunately the signature and date on a canvas in the Musée des Beaux-Arts at Nantes (fig. 1) are so worn that it is not clear whether it should be read as 1640 or 1646.[5] The *Sleeping Nymphs* (no. 25) is probably the finest of the pictures in a vein which Lely abandoned in the 1650s. They are close in design, iconography and handling to Dutch, and to a lesser extent Flemish, prototypes. The painter who had been most prolific in this vein in England was Cornelis van Poelenburgh. In particular, Lely's clumps of rather awkwardly drawn sleeping nymphs are very reminiscent of Poelenburgh (fig. 2), although in Lely's more mature compositions in this style the figures and heads become more refined. One can also find parallels,

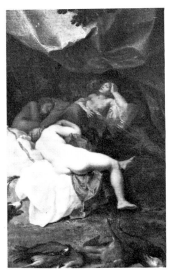

Fig. 1 *Diana and Nymphs bathing*. Musée des Beaux-Arts, Nantes

Fig. 2 Cornelis van Poelenburgh, *Cimon and Iphigenia* (detail). Centraal Museum, Utrecht

sometimes startlingly close, to these early works by Lely in compositions by such painters as Jacob van Loo, Dirck van der Lisse, Johan Danckerts,[6] Abraham van Cuylenburg,[7] Jacob Adriaensz. Backer,[8] Govert Flinck[9] or Jan Gerritsz. van Bronchorst.[10] The only figure-drawing by Lely (fig. 3) which can at the moment be associated with a subject-picture, a study for a reclining nude in a *Cimon and Iphigenia* at Doddington Hall, is close in handling to drawings by Flinck.[11]

There is also in Lely's early compositions a neo-Venetian strain distilled through the powerful influence of Van Dyck. These two influences had been fused in the little subject-pictures painted in England, not long before Lely's arrival, by Frans Wouters; something of Wouters's pretty Venetian colour and Venetian cast of countenance can perhaps be seen in Lely's *Infant Bacchus* (no. 15). Lely also owned for a time the loveliest picture ever painted in England in this mood: Van Dyck's *Cupid and Psyche*. But the picture most startlingly close to Lely in scale, type and design is the one which hangs behind Vermeer's *Lady Writing a Letter* (fig. 4).

The most beautiful of Lely's early landscapes with small figures is the *Concert* (no. 11). Painted with a fresh and nervous touch, in a lovely range of clear colour – in these qualities unrivalled among pictures painted in England between the death of Van Dyck and the advent of Gainsborough – its slightly raffish atmosphere is compounded of elements from the Dutch pastoral tradition and romantic recollections of sixteenth-century *fêtes-champêtres*; the bonnet and shirt which the chief musician wears suggest both Venice and Utrecht. The *Bass Viol Player* by Terbrugghen is another of the royal pictures which Lely for a time owned. The *Concert* and the remarkable series of musicians, of which three (nos. 12, 13 and 14) hang in the exhibition, and which are close in subject-matter, if not in mood, to Terbrugghen, remind one of Lely's love of music; and they tell us something of the world he would have known in the course of his friendship with the cavalier poet Richard Lovelace.

On 26 October 1647 Lely was made free of the Painter-Stainers Company; Thomas Rawlins, Graver to the King's Mint, and Lovelace were made free on the same occasion.[12]

The poet's *Lucasta, Posthume Poems* (1660) included the lines on *Peinture*, written as '*A Panegyrick to the best Picture of Friendship Mr* Pet Lilly', in which Lovelace commiserates with him for the 'transalpine barbarous Neglect' with which his early pictures had been regarded in England, an 'un-understanding land', where only portraits were in demand : 'Let them their own dull counterfeits adore . . . Within one shade of thine more substance is Than all their varnish'd Idol-Mistresses'.[13] The couple in the *Music Lesson* of 1654 (no. 24), so near in subject and mood to Metsu, could well be learning one of the songs of Lovelace set by Henry Lawes, John Wilson or John Lanier.[14] In an earlier collection, *Lucasta* (1649), Lovelace had printed his famous tribute to Lely's portrait of Charles I and the Duke of York (no. 6) – '*that excellent Picture drawne . . . at* Hampton Court'. This poignant likeness of 'a *clouded Majesty*' had been commissioned by the Earl of Northumberland, together with the group of three of the king's children (no. 7). In an uncertain world, so far as artistic patronage as well as politics were concerned, Lely was already, in unpropitious times, characteristically well placed. Cornelius Johnson had gone over to Holland ; William Dobson, the most gifted painter in England and attached until 1646 to the wartime court at Oxford, had died in poverty the previous autumn. Lely was working for the group of peers, closely related by marriage, interest, political sympathy and a puritan dislike of Laudianism – the 'noble defectors', Northumberland, Leicester, Salisbury and Pembroke – who had remained in London during the conflict. In the halcyon days they had been prominent at court and lavish patrons of Van Dyck.

On the walls of their London houses Lely would have seen for the first time a splendid range of portraits by Van Dyck ; and it was natural that when he set out to build up a practice as a portrait-painter, he should consciously and with the encouragement of his patrons model his style on his predecessor's. Lely was never to become so subtle, refined or romantic a painter, but the derivations in his early portraits are obvious : recollections of Van Dyck's royal groups in the sequel painted for Northumberland (no. 7) ; a pastiche (no. 10) of one of the full-lengths by Van Dyck (fig. 5) in the series assembled by the rich Puritan and Parliamentarian Lord Wharton ; or an attempt to emulate Van Dyck's rhythms and colour in the portrait of Richard Gibson and his wife (no. 18). In Lely's portraits the contrasts between light and shade are harsher, and the paint thicker and more directly applied than in the work of Van Dyck ; the range of colour is quite personal to him, with nothing of Van Dyck's alternately silvery or glowing Venetian tone ;

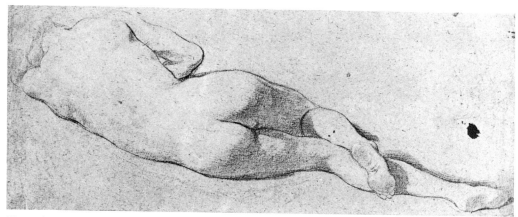

Fig. 3 *Study for a reclining Female Figure*. European Fine Art Gallery, Dublin

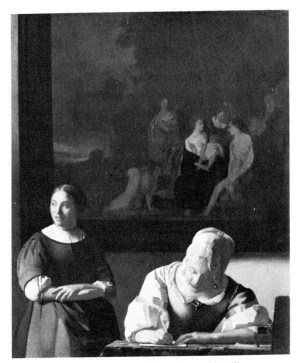

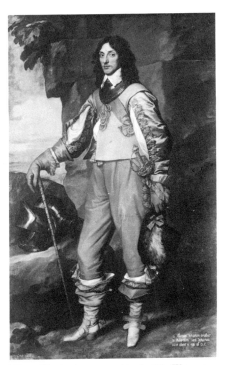

Fig.4 Jan Vermeer, *Lady writing a Letter* (detail). Beit Collection

Fig.5 Sir Anthony van Dyck, *Sir Thomas Wharton*. Hermitage Museum, Leningrad

and the individual parts of a figure, even the separate features in a face, are often not quite happily coordinated. The figures are clumsily articulated, as if the clothes and draperies had been put on a lay figure. In portraits on a smaller scale the sitter is often placed unconvincingly within the limits of the design. These are weaknesses which Lely did not entirely overcome until the later 1650s. 'One of the eyes was out, so I said onely that Mr Lilly should mend it'.[16]

It is possible that a small group of portraits, represented by two particularly charming examples in the exhibition (nos. 2 and 3) and by a portrait (no. 5) which is perhaps the masterpiece of its type, should be dated slightly earlier than portraits which are so deliberately Van Dyckian. Simple in design and colour (with noticeably less pigment than in the works of 1647), they have a restraint uncharacteristic of much of Lely's later work; and the creamy flesh and simple patterns of black and white in the costume are reminiscent of a painter such as Van der Helst, Backer or Jacob van Loo.[17]

The landscapes in Lely's portraits of the late 1640s are richly atmospheric, with a suggestion of the Dutch Italianate landscape painters whose work he would have known in Holland. And in his work for Pembroke and Leicester he sounds an Arcadian note with echoes of Waller or Sir Philip Sidney. Lely, whose library contained Spenser and Tasso, had in fact already designed a little plate in this vein for *Lucasta*, and the figure of young Henry Sidney as a shepherd (no. 19) could well illustrate an anthology of pastoral verse. There are, again, prototypes for this portrait in Van Dyck, but the closest parallels are with figures in outdoor conversation pieces by such Van Dyckian painters as Jan Mytens or Gonzales Coques. The masterpiece in this vein is the beautifully painted *Shepherd Boy* (no. 28), young Corydon with his oaten flute, who masqueraded for many years as Abraham Cowley.

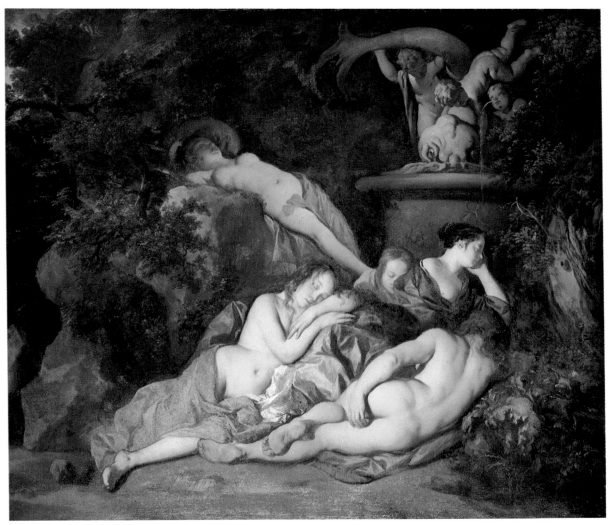

Colour plate II *Sleeping Nymphs by a Fountain* (no. 25)

Prominently displayed in many of Lely's designs throughout his career are large pieces of sculpture, which sometimes incorporate a fountain or jet of water. Prototypes can again be quoted from Van Dyck; but the specifically Dutch or Flemish baroque character of Lely's richly carved sculpture has marked affinities with, for example, the sculpture being made at this period by Artus I Quellin for the Town Hall in Amsterdam.[18] Lely himself owned, by the end of his life, examples of antique, renaissance and contemporary sculpture, including works by Duquesnoy and 'The Head and Busto of Mr. *Baker*, in White Marble, by *Cavalier Bernini*'; and as a young man he would have had unlimited opportunity to study in the vast collections of antique and renaissance sculpture assembled by the king, the Duke of Buckingham and the Earl of Arundel.

Even in the portraits of 1647 there is, for all their structural weakness, a sheer quality in the use of paint, passages of strong draughtsmanship, assured modelling and an overall richness of texture which no other painter in England could attain; and by 1654, at the time of the commission to paint Oliver Cromwell (no. 22), Lely is described as 'the best artist in England'. At about the same time, however, Dorothy Osborne was complaining that Lely 'was condemned for makeing the first hee drew for mee a litle worse then I, and in makeing this better hee has made it as unlike as tother'; although he protested that he had never taken more pains 'to make a good one'.[19]

Before the dissolution of the Long Parliament in April 1653, Lely, in company with George Geldorp, with whom he may have worked in the 1640s, and the arch-opportunist Sir Balthasar Gerbier, put up a scheme to Parliament for a series of pictures, to be placed in the palace of Whitehall, representing all the memorable achievements since the Parliament's first sitting. They cited as a precedent the famous set of Armada tapestries with portraits of the principal commanders in the border, and suggested pictures of the principal battles and sieges of the Civil War, 'beset' with portraits of the appropriate generals and commanders. For positions at either end of the Banqueting House, under Rubens's ceiling, they proposed two large group-portraits in the Dutch tradition: the 'whole Assemblie of Parliament' at one end, the Council of State at the other.[20] Never attached to the old court and thus unaffected – directly, at least – by its exquisite culture and, until they were being scattered, by the works of art for which it had been so notable, the emergence of this tough, level-headed young Dutchman, and the importance to his success of the support of the 'noble defectors', are among the most significant points in the history of connoisseurship and the arts in the Civil War and Interregnum.

One of the Protector's friends and one of Lely's most influential patrons in these difficult years was the Countess of Dysart (no. 23). At least two of the young men whose portraits were hung in the long gallery at Ham were deeply entangled in the ultra-royalist Sealed Knot. In 1652 Northumberland's daughter, Lady Elizabeth Percy, married the young Lord Capel whose father had lost his head in the royal cause. The family was very rich, and for them and for their royalist relations – Dormers, Somersets and, later, Hydes – Lely produced some of his most accomplished pieces before the restoration of the king. A friendship grew up between Lely, the younger Capel brother, Henry, and Hugh May, whose success as an architect after the Restoration was partly due to his loyalty as a royalist agent under the Commonwealth. In June 1650 May was lodging 'att Mr Lilyes a picture drawer', in a house on the Piazza in Covent Garden which was also occupied by Tobias Flushier or Flesshiers.[21] May was travelling back and forth between London and the Continent, and in the summer of 1656 Lely was in his company on a journey to Holland.[22] They were carrying, it was claimed, nothing prejudicial to the

State, and Lely must have required from time to time to look after his property and affairs in The Hague; but at the very least his association with May stood him in good stead at the Restoration, and involvement with the exiles may have gone deeper.

The Restoration

At the Restoration Lely was the best portrait painter 'in large' in England. Compared with the others who were listed with him by William Sanderson in 1658 among painters 'In the Life' – Walker, Soest, Hayls, Wright, Sheppard and Des Granges[23] – he was more prosperous and had more influential patrons. He was soon painting the chief men and women of the Restoration world, and it was inevitable that he should come to be officially regarded as Van Dyck's successor. In October 1661 he was granted by the king an annual pension, as Principal Painter, of £200 'as formerly to Sr Vandyke' and to run from the previous June; by the summer of 1662 he had been granted naturalisation.[24] The grand way of life which he led in the house on the Piazza was probably in conscious emulation of the cultivated, gentlemanly existence that Van Dyck had led in Whitehall and Blackfriars before the Civil War. 'He lives very gently and treated us nobly at a Dinner';[25] and Samuel Pepys was impressed by the pomp with which his dinner was laid: 'but a mighty proud man he is, and full of state'. He was knighted in January 1680. The Florentine Lorenzo Magalotti, visiting London in 1667–8, mentions as the most famous painters in London only Cooper and Lely.[26]

The king, according to Magalotti, had commissioned from Lely a very beautiful picture (for which Magalotti actually saw the sketch): an Arcadian scene in which the loveliest ladies of the court were to be painted, on the scale of life, as nymphs. Thoughts of this may have encouraged the Duke of York to commission the famous 'Windsor Beauties' which, with the portraits painted for Sunderland (e.g. no. 45), are the most familiar type of portrait to have come out of the studio in Covent Garden. In them Lely expresses unequivocally the luxuriant, sensuous aspects of the Restoration world. To Pope, describing that world in a famous passage, Lely was an essential part of the scene:

In Days of Ease, when now the weary Sword

Was sheath'd, and *Luxury* with *Charles* restor'd; . . .

Lely on animated Canvas stole

The sleepy Eye, that spoke the melting soul.

No wonder then, when all was Love and Sport,

The willing Muses were debauch'd at Court.[27]

By now Lely had overcome the awkwardnesses apparent in his earlier designs. The figures stand or relax with ease in the canvas, spread themselves over it or move confidently across it. The texture is extremely rich, the paint strong and fluent, the colour clear and resonant and of a subtlety beyond the range of any rival, the composition sometimes flooded with light. Striking examples of his full Restoration style are the pair of portraits (nos. 32 and 33) painted for Lord Clarendon's gallery. The extent of Lely's stylistic advance can be gauged by comparing the *Cotton Family* (no. 30) of 1660 with the *Perryer Family* (no. 26) painted five years earlier.

The studio

When Samuel Pepys called with Peter Pett on Lely on 20 October 1662, the painter, thinking they had come to commission a portrait, said he would not be at leisure for three weeks; when Pepys visited him on 18 July 1666 with Sir William Penn, whose likeness

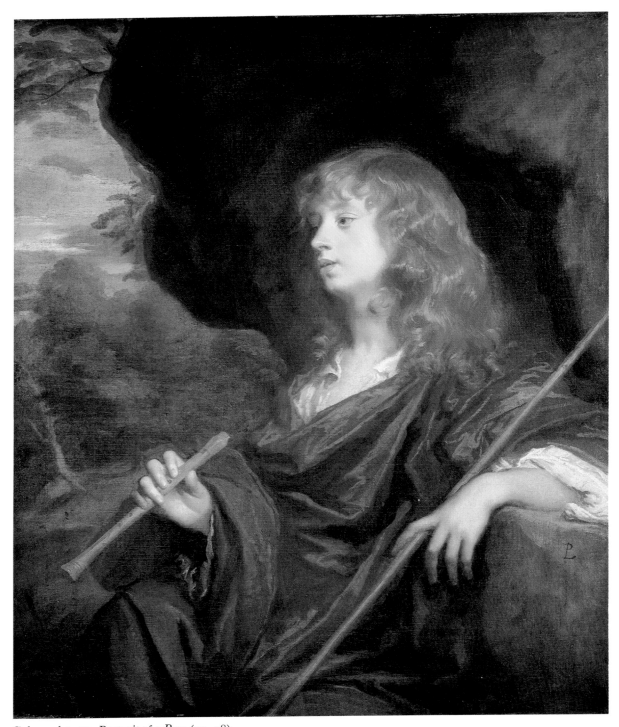

Colour plate III *Portrait of a Boy* (no. 28)

was to be included among those being painted for the Duke of York, Lely was so full of work that he had to consult his 'table-book' and make an appointment for six days later between seven and eight in the morning. Once a sitting had been arranged a patron would be offered first a rapid chalk drawing of a suggested design (e.g. nos. 62, 63 and 64); there are indications that oil-sketches were also occasionally produced, in the tradition of Rubens and Van Dyck.[28] Once a pose had been chosen, sittings would be given and the head painted from life: Lely at his easel, six feet from the window with the light falling over his left shoulder, the sitter also six feet from the light and from the painter.[29] To very important sitters Lely would take his equipment and set it up in their apartments.[30] The head of the Duke of York (no. 41), probably painted in the Duke's lodgings, represents perhaps all that would have been painted when the sitter was confronting the painter. According to one account, related in 1673, Lely 'slightly chalks out the body', after he had laid in the face, 'the person sitting in his intended posture'; and also laid in the colouring of the hands and garments. 'He does all this by the life presently whilst the person stays so you have a picture in an instant'.[31]

As the pressure of business became more and more taxing Lely was compelled to employ assistants, so that a very large number of portraits could be produced as quickly as possible. He himself worked very hard, painting, according to tradition, from 9 to 4, but could not conceivably cope with the demand for large quantities of copies of new portraits, especially of the royal family and of the more spectacular ladies, and for sets of portraits for important clients at home and abroad. This demand could only be met by putting the assistants on to painting everything but the head, after the design had been laid out for them. The head of the Duke of York, or of Sir John Harman (no. 40) as seen in X-ray (fig. 14), indicates the extent of Lely's part in a commission; and in the case of Harman a competent assistant could be trusted to paint the rest of the figure. Other assistants would paint the background. It is noticeable that Lely's heads, certainly in such famous series as the 'Flaggmen', are now treated in a more direct and simplified manner than, for instance, the head of the *Shepherd Boy* (no. 28). His patrons became increasingly apprehensive. A friend of Sir Thomas Isham (no. 56) warned him near the end of Lely's career that 'I have know Sr Peter Leley change an origenall, for a coppy, especially to thos that don't understand pictors'; and Lely had to write, on 1 December 1677, an attestation for Sir Richard Newdegate (no. 55) that two portraits done for him had been 'from the Beginning to ye end drawne with my owne hands'.[32]

In Lely's studio at his death there were well over a hundred original canvases and an enormous number of copies: of the king, for example, five full-lengths, nine half-lengths and three heads, and twelve half-lengths of the Duchess of Cleveland. The postures which could be offered to prospective patrons were classified by numbers. When Lely's pupils (and other painters) bought from the studio after his death, they were happy to acquire such lots as '14. halfe lengths outlines', 'Whole length postures No.8 & 1. and 1. cloth and hand on it', or 'S.r Ralph Verney $\frac{1}{2}$ 49'.[33] Enough drawings survive (e.g. nos. 62 to 69) to indicate the important part they played in the organisation of the practice and the evolution of designs.

Costume

A word should be said about the costumes in which Lely's sitters were portrayed. By contrast with Michael Wright, Soest or Samuel Cooper it is remarkable how few of them are shown in the ordinary dress in which they would have walked abroad. Apart from the

Fig. 6 John Michael Wright, *The 4th Earl of Salisbury and Lady Catherine Cecil.*
By courtesy of the Marquess of Salisbury

sovereign or his peers in robes of state ('parliament robes'), civic dignitaries, law officers, churchmen, Knights of the Garter in the newly-designed robes of the Order or men of action in breastplate and buff doublet, almost all the men, women and children in Lely's portraits wear less formal, and thus less strictly contemporary, dress. It is, for example, very rare to find one of his female sitters in the stiffly boned and carefully ordered dress in which she would have been seen out of doors. Marshall Smith, in his *Art of Painting* (1692), was not, however, quite accurate in claiming that Lely had 'brought up first the curious *Loose-Dressing* of *Pictures*, which most of our Masters since have follow'd'. Loose and easy male vests, and night-gowns and other forms of female undress, had been used by Van Dyck.

Although certain writers thought it much more pleasant to see the portrait of an old friend or relation 'painted as he was, than a foppish nightgown, and odd quoifure, which never belonged to the person painted', a fashionable portrait by Wright (fig. 6) or Soest could, with its mass of distracting detail, rapidly seem dated by contrast with Indian gowns, shifts or classical armour. The night-gown is worn by Anne Hyde (no. 33), Lady Chesterfield (no. 34) and the Duchess of Portsmouth; the charms of Anne Bickerton and Diana Kirke are shown to advantage in the shift. Hugh May (no. 51) and Lord Clifford (no. 42) wear Indian gowns, and Sir John Cotton (no. 30) a good example of the vest; Sir Robert Holmes (no. 48) wears an exotic oriental headdress with a vest; Sir Thomas Isham (no. 56) is dressed in the popular form of classical Roman kit, which has close association with the theatre and the masquerade. In the portrait of the Gibsons (no. 18), of Henry Sidney (no. 19) or of the chief musician in the *Concert* (no. 11), there is a picturesque anthology of Arcadian dress with mingled recollections of Van Dyck and the Dutch pastoral tradition.[34]

The assistants and rivals

In the autumn of 1648 the young Robert Hooke had gone to London to be apprenticed to Lely, and in November 1652 Lely asked the Painter-Stainers if an apprentice could be

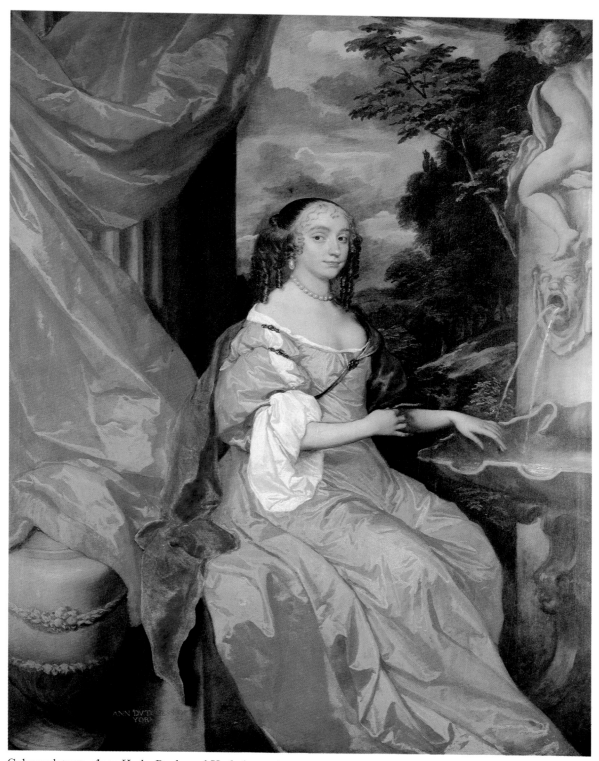

Colour plate IV *Anne Hyde, Duchess of York* (no. 33)

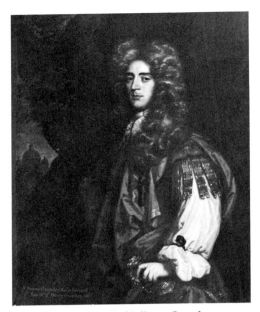

Fig. 7 John Greenhill, *Sir James Oxenden*.
Richard Jeffree, Esq

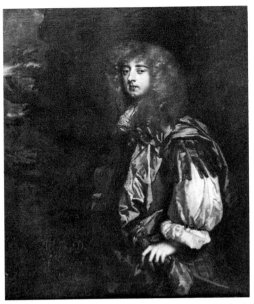

Fig. 8 *William, 3rd Duke of Somerset*. The Duke of
Beaufort

turned over to him.[35] After the Restoration his most promising assistant was probably
John Greenhill (fig. 7), whose independent work remained much influenced by Lely
(fig. 8). The drapery-painter John Baptist Gaspars ('*Lely's Baptist*') worked with Lely for
many years and, after his death, continued in the service of Riley and Kneller. He may
well have worked on the *Flagmen* and on the portraits for Clarendon; certainly one
notices in a number of portraits by Riley the simplified, blocked-out draperies and rather
dull tone familiar from those two sets. During Lely's later years the most skilled assistant,
among a large number working in the studio, was probably Prosper Henry Lankrink, who
specialised in painting grounds, landscapes, flowers and ornaments; in the 1670s
Nicolas de Largillierre was briefly associated with Lely, and a study of grapes (fig. 9)
painted at this time may have been produced for use in the studio.

Of the others, the most successful after Lely's death were Thomas Hawker, who painted
in a style (fig. 10) which is a coarse and flamboyant variant on Lely's late manner; and
Willem Wissing, who took on much of Lely's fashionable practice and could offer patrons
the same repertory of patterns. For many years Lely had been on friendly terms with the
Beale family. He encouraged Mary Beale, by lending her (and her sons) pictures and
drawings from his collection to be copied, and by allowing her to study his own technical
methods. She repeatedly made use of patterns or devices current in the studio.[36] Lely
could also see his work reaching a wider public through engravings. He probably did not
establish a close professional partnership with a particular engraver, as Kneller was to do
with John Smith, but the line-engravers and the early engravers in mezzotint – Blooteling,
Valck, Beckett, Tompson, Browne and the like – issued during Lely's lifetime a large
number of fine prints after his portraits.

Lely himself, at the heart of his flourishing organisation, continued to forge new designs
and to evolve changes in his technique. From the later 1660s his colour becomes less
bright and his paint thinner and drier. In 1672 the Beales found this 'a more conceiled
misterious scanty way of painting then the way he used formerly.' At the same time the

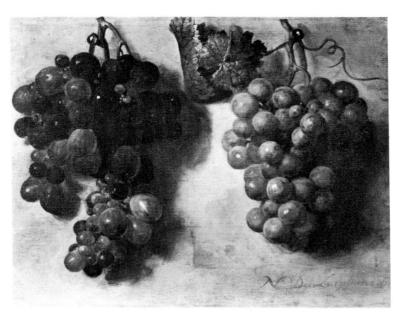

Fig. 9 Nicolas de Largillierre, *A Study of Grapes*. Fondation Custodia
(Coll F. Lugt), Institut Néerlandais, Paris

drawing of the draperies became more formalized, as if to make them easier for a pupil to
copy. Some of the latest portraits are almost monochrome, the dragged paint, often over
darkish underpaint, and sombre colour imparting a richly atmospheric effect, enlivened
by touches of liquid impasto which display the mastery of touch unimpaired by thirty
years of unremitting work.

By sheer tenacity Lely retained his supremacy over his principal rivals. None of his
chief contemporaries, Wright, Soest or Huysmans, was so consistently successful. The
Frenchified artists, the Vignons, Simon Verelst or Henri Gascars – 'the florid Cascar' of
Roger North's contemptuous note, had not been serious rivals for long, in spite of the
formidable support they could count on from influential patrons at court. When, in 1676,
the Painter-Stainers planned to commission a set of royal portraits, it was proposed to ask
Greenhill to paint the Duchess of York, Wright the Duke and Huysmans the queen. The
king was to be painted by Lely.[37] In the same year, however, the young Godfrey Kneller
had painted his first important English patron. The immediate success at court of this
confident young foreigner was a mortal blow, ironically reminiscent of Lely's own early
good fortune in London. If there is truth in the story of the Duke of Monmouth persuad-
ing the king to sit to his new protégé at the same time as Lely was to paint him for the
Duke of York – of a competition in public between the painter of settled reputation and a
fast-working rival, full of fire and ambition and with rooms in Whitehall itself – Kneller's
success could have been lethal.[38] According to Houbraken, Kneller's success, although he
pretended to be indifferent to it, preyed on Lely's mind. He relied on his friend and
physician, Dr William Stokeham, to provide him with news of it on his daily visits to the
studio. On one of these visits, on 30 November 1680, the doctor found him far from well,
but about to start on the day's work: busy preparing his palette in readiness for a sitting
from a female client. The doctor felt his pulse and urged him to rest. Lely, unwilling to
break his routine, said he had no time. After the doctor had left, he collapsed in an
apoplectic fit and died.[39] He was buried in St Paul's, Covent Garden, on 7 December.

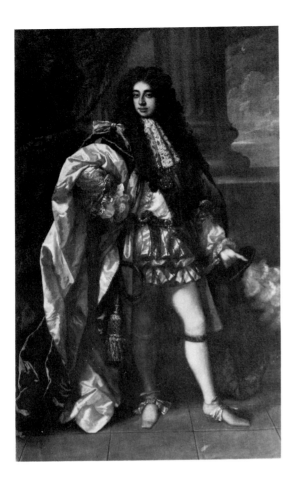

Fig. 10 Thomas Hawker, *Henry, 1st Duke of Grafton.* The Duke of Grafton

The estate and collections

Lely should have died a rich man. In addition to the fees from his practice, there was his annual salary from the Crown, though this was often in arrears, and interest from substantial investments. He acquired property in Surrey (at Kew) and Lincolnshire. 'Averse to business', Lely was, however, in need of professional help in settling his affairs and securing the welfare, after his death, of his children, Anne (no. 84) and John (no. 83), a 'comely boy, but much given to mean company'. Ursula, 'his reputed wife', had married him after their birth, and she had died in January 1674, giving birth to another son, Peter, who was buried in St Paul's five days after his mother.

 In the circle of his 'chief virtuoso friends' – Hugh May, Sir Samuel Morland and Henry Capel – Lely had made the acquaintance of the Norths. The eldest brother, Lord Guildford, the Lord Keeper, was a lover of painting and gave Lely advice on his affairs. In return Lely talked to him about pictures, illustrating their discussions with observations on prints and drawings – 'a magazine of Scizzis and drawings of divers finishings' – from his great collection: 'Sir Peter was a well-bred gentleman friendly and free, and not only an adept in his art but communicative'. The youngest brother, Roger (no. 59), became a trustee of Lely's estate and executor of his will (with May and Dr Stokeham). The estate was encumbered with legacies and debts which amounted to nearly £9,000.

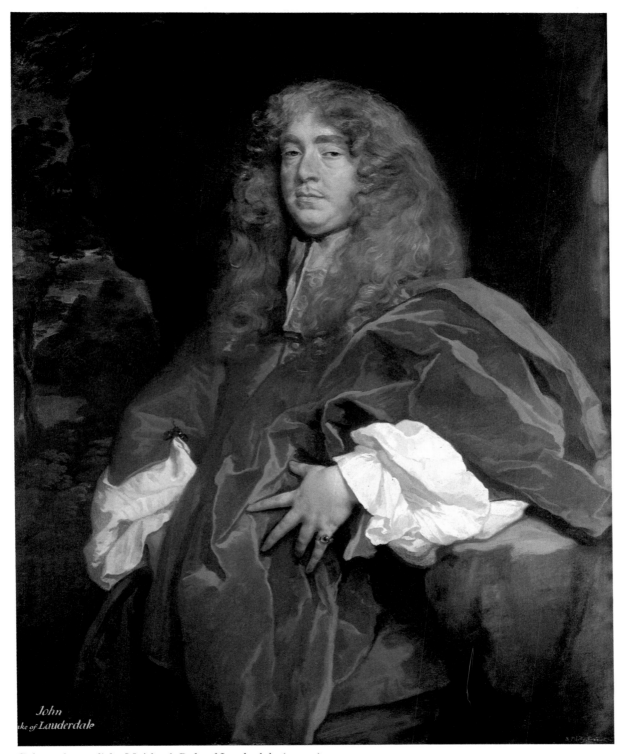

Colour plate v *John Maitland, Duke of Lauderdale* (no. 37)

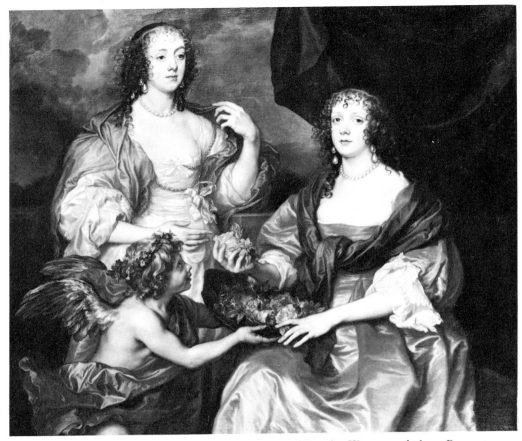

Fig. 11 Sir Anthony van Dyck, *Lady Elizabeth Thimbleby and Dorothy, Viscountess Andover.* By courtesy of the Trustees, the National Gallery, London

North organised with exemplary efficiency the sale of Lely's studio effects, possessions and works of art.[40]

The sale of the pictures, 'that nice and critical part of our trusted estate', fetched above £6,000; from a sale of a number of the prints and drawings, put in order and marked by North with the familiar stamp, more than £2,400 was raised. The prints and drawings were sold on 11 April 1688 (and following days); a second sale began on 15 November 1694. The pictures had been auctioned on 18 April 1682.

Lely had probably begun to collect in the late 1640s. At the sale of the king's goods he had bought an expensive Veronese. a Breenbergh and a picture attributed to Tintoretto; and at the Restoration he was in possession of a bronze, a group of marbles and pictures which included the Terbrugghen, two Van Dycks (the *Three Eldest Children of Charles I* and *Cupid and Psyche*) and pieces by Caroselli, Fetti and Miereveld.[41] All had to be ceded to the Crown. In the 1650s Lely met (and painted) Everhard Jabach;[42] and at some period secured drawings from the collections of the Earl of Arundel and Nicholas Lanier with whom he had had conversations about Van Dyck's technique. By the early 1660s Lely's collection was very impressive. The huge collection of drawings, the first to be formed by a painter-collector in this country, included examples by Pordenone, Veronese, Giulio Romano, Raphael (among them the cartoon for *La Belle Jardinière*), Fra Bartolommeo, Leonardo, Polidoro, Correggio, Primaticcio, Barocci, Taddeo Zuccaro and Parmigianino;[43]

24

and one at least of Van Dyck's two surviving sketchbooks. The chief glory of the paintings was probably the group of works by Van Dyck, '*being* his *best Pieces*': twenty-five items as well as the *modello* for the Garter Procession and thirty-seven sketches on panel for the *Iconography*. Among them was the double-portrait (fig. 11), recently acquired by the National Gallery, of Viscountess Andover and Lady Elizabeth Thimbleby. When it hung in the gallery at Althorp, surrounded by so many of the ladies painted for the Earl of Sunderland by Lely, it demonstrated the extent of Van Dyck's influence on Lely: '*LELI Anglois, a fort fait bien les Portraits dans la manière de Vandeik, tant pour les têtes que pour les habits & les ajustemens*'.[44]

According to Graham, Lely had as a young man been earnest to visit Italy but had been prevented by his 'great business', and had resolved to make amends by forming a collection. Towards the end of his life he talked to Charles Beale about the high value experts had put on it. 'For Drawings & Prints his was the best Collection in Europ. He told me . . . that Rimbrant had given £100 for ten prints, & that himself had most of those ten prints in his Collection . . . severall prints after Rafael Urbin in his Collection cost him 7, & 8[li] a print . . .'[45] The collections gave Lely authority as an adviser on artistic matters, sometimes in association with Gibbons, who was later to receive £125 from Lely's executors for the monument, crowned with a bust of his friend, erected in St Paul's Church. To help him with this, 'Sr Peters picture' had been taken to his workshop on 5 March 1685. The epitaph was composed by Thomas Flatman.[46] The monument was destroyed in the fire of 1795.

Conclusion

If Lely was 'the late noble painter' of whom Dryden was thinking when he was composing his *Preface* to *Sylvæ* of 1685,[47] he was repeating criticism that had been heard in the painter's lifetime. 'It was objected . . . that he drew many graceful pictures, but few of them were like. And this happened to him, because he always studied himself more than those who sat to him.' Pepys, who had seen the Duchess of York sitting to Lely on 24 March 1666, considered that even after two or three sittings the portrait would not be a resemblance, 'the lines not being in proportion to those of her face'; and in 1676 Lady Chaworth asked a copyist, in preparing for her a copy of her brother's portrait, to 'correct Mr. Lilie's fault towards all men in wronging by making blacker, older, and moroser in his draughts then they are'.[48]

Robert Walker was said to have sworn, many years earlier, that Lely's sitters were all brothers and sisters (see no. 45); slightly later critics such as Graham and Buckeridge praise his sound drawing, fine colour, varied and graceful postures and flowing draperies, but point out the 'languishing Air, long Eyes, and a Drowzy Sweetness peculiar to himself, for which they reckon him a *Mannerist*'[49]. Contemporary artists, however, rightly admired the technique – 'finely drawn & a fine touch with the Pensil' – of a painter who had for so long been the best in London. The unexpected charm of the early works, with a vein of poetry too soon to be worked out; the rich texture, fine colour and lively air of the portraits with which he first made his name; the glamour of the early Restoration canvases; and the atmospheric quality of the late work; make a more consistently splendid impression than the work of any other painter working in England on the scale of life between Dobson and Hogarth. His drawings have a strength and a sheer professionalism, and sometimes an unexpected tenderness, beyond any of his contemporaries in London. Lely lacked the magnificent technical gifts of the best of his fellow-Dutchmen,

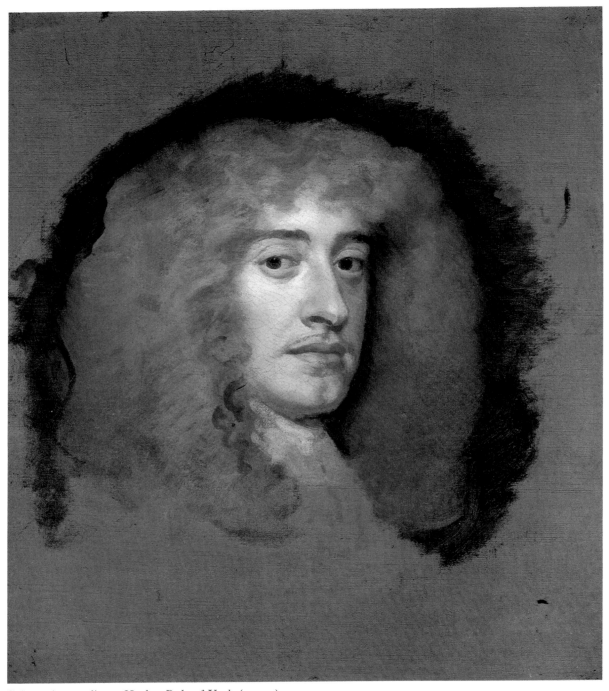

Colour plate VI *James II when Duke of York* (no. 41)

painters such as Van der Helst or Maes, and rarely conveys the friendly charm with which their sitters engage us; but he was a much better painter than the other professional court painters of the day, after the passing of the heroic generation. It was younger contemporaries in France, among them Largillierre, who had worked with him briefly in London, who were to give the baroque portrait a new panache, based on a fresh approach to Rubens and Van Dyck and presented with brilliant technical skill.

The quality of his work apart, Lely's principal achievement in the history of British painting was to develop the methods which had first been devised by Van Dyck in his studio at Blackfriars in the 1630s to deal with a large practice. In the great fashionable portrait-painter of the age of Charles II, who has stamped on our imagination so indelible an impression of the Restoration scene, a strain of cynicism may have been difficult to suppress. 'For God's sake, Sir Peter', he is reported to have been asked by a friend, 'how came you to have so great a reputation? You know that I know you are no painter.' 'My Lord, I know I am not, but I am the best you have.'[50] In relaxed moments, drinking with virtuoso friends the rare but heady wine which Hooke enjoyed under his roof, Lely may have dreamed, as Van Dyck had done, of escaping from the demands of the practice. When he entertained Sir William Petty and some very good company to dinner one day in June 1675, he told them he was 'Ambitious to make us an Immortall picture'.[51] Lely's reputation has suffered because it has been made to rest so often on portraits in which he himself had had no part and because among the portraits he did paint there is not sufficient variety in scale, in layout or in the relationship between the sitter and the spectator; but he breaks down this uniformity in such late works as the *Isham* (no. 56) and *Dysart* (no. 58). For a sympathetic insight into character, and into idiosyncrasies in appearance – for the equivalent in paint of the written word of Samuel Pepys – one turns instinctively to Lely's Covent Garden neighbour, Samuel Cooper; but his own lustrous canvases are a no less essential expression of the extravagance, authority and vigour of the Restoration spirit.

Notes to the Introduction

[1] J. A. C. Ab. Wittenaar, 'De Geboorteplaats en de Naam van Pieter Lely Nieuwe Documenten', *Oud-Holland*, LXVII, part II, Amsterdam 1952, pp. 122–4. In April 1652 the painter and his sister, Catherina (or Anna Catherina) Maria, married to Conradt Wecke, burgomaster of Groll, were among the heirs to the property of an aunt, Odilia van der Faes: an inheritance which included the house *in de Lelye*. By this date Captain van der Faes was dead. An uncle, Olivier van der Faes, was a merchant dealing in silk sheets and captain of the White Company, the *Witte Vendel*, of the sharp-shooters in The Hague.

[2] '. . . alle sijn niet aangegeeven ende noch onbetaelde discipulen . . .'

[3] Richard Graham in the *Short Account* of ancient and modern painters attached to the English edition, *The Art of Painting . . . with Remarks*, 1695, of Du Fresnoy's *De Arte Graphica*, pp. 343–4.

[4] Arnold Houbraken, *De Groote Schouburgh der Nederlantsche Konstschilders en Schilderessen*, II, Amsterdam 1719, pp. 33–8; J. C. Weyerman, *De Levens-Beschryvingen der Nederlandsche Konst-Schilders en Konst-Schilderessen*, The Hague 1729, II, pp. 142–7.

[5] No. 425 in the *Catalogue* of 1953.

[6] In reproduction at least a *Cimon and Iphigenia* (a subject Lely painted at least twice), signed and dated 1648 by Danckerts, is indistinguishable from Lely (art-market in Berlin, 1940, 1942; Hamburg, 1945).

[7] See his *Cimon and Iphigenia* in a private collection in Budapest (*Bulletin du Musée Hongrois des Beaux-Arts*, no. 23, Budapest 1963, p. 55).

[8] His *Cimon*, for example, in the Kunsthalle, Bremen, or *Sleeping Nymphs* in Brunswick.

[9] A (signed) group of nude figures by a fountain, for example, with Cevat in Amsterdam, 1938.

[10] *Sleeping Nymphs* (signed), on the art-market in Leipzig, 1933.

[11] Formerly in the C. R. Rudolf collection, exhibited at the Arts Council, 1962 (no. 133, as attributed to Rubens); Rudolf sale, Sotheby Mak van Waay B.V., Amsterdam, 18 April 1977 (40).

[12] The Company's 'Booke of Orders and Constitutions', I, f. 221.

[13] *The Poems of Richard Lovelace*, ed. C. H. Wilkinson, 1930, pp. 180–1.

[14] The girl can be recognised as a model used by Lely on a number of occasions. Was she perhaps the 'Mrs. Gratiana', of whom a drawing by Lely was sold after his death and who may have been the 'Gratiana' whose dancing and singing had delighted Lovelace?

[15] *Poems*, op. cit. pp. 57–8.

[16] Diary of Henry Osborne, 7 March 1655 (*The Letters of Dorothy Osborne to William Temple*, ed. G. C. Moore Smith, 1928, p. 192).

[17] Unfortunately the identities of many of the sitters in these early portraits are lost.

[18] I am grateful to Dr Charles Avery for this suggestion. For the decoration of the Town Hall, see K. G. Fremantle, *The Baroque Town-Hall of Amsterdam*, Utrecht 1959.

[19] Letter to William Temple, October 1653 (*Letters*, op. cit. p. 106).

[20] B.M., Stowe MS 184, f. 283; printed in Collins Baker, II, p. 132.

[21] Cottrell-Dormer MSS at Rousham; Rate-Books for the Westminster area, preserved in the Westminster Public Library. Lely and Flushier paid rates jointly for the house, in this very smart quarter, in 1651 and 1657, Flushier by himself 1652–6 and 1658–61. Lely at first seems to have lodged in the house and in due course, certainly by 1662, to have become its sole tenant; from 1662 he is the only ratepayer in the house. As you turned left on coming into the Piazza from James Street the house was the fifth on your left from the corner. In the assessments of rates in Covent Garden for 1651 Lely's name is inserted slightly later.

[22] Public Record Office, State Papers, Domestic 25/77, 150, order, 29 May 1656, for a pass for Holland to be granted to 'Peter Leley, and his Serv.t Hugh May'.

[23] W. Sanderson, *Graphice*, 1658, p. 20.

[24] P.R.O., S.P.44/5,27; 38/21, Docquett 22; *Huguenot Society*, XVIII, ed. W. A. Shaw, 1911, p. 82.

[25] *Conway Letters*, ed. Marjorie Hope Nicolson, Yale 1930, pp. 333–4 (Henry More to Lady Conway, 29 May 1671).

[26] A. M. Crinò, *Fatti e Figure del Seicento Anglo-Toscano*, Florence 1957, p. 165: '. . . è ricchissimo, e si tratta nobilmente . . . huomo forse di quarantacinque anni, ma ben fatto, cortesissimo al maggior segno'.

[27] *Imitations of Horace* (Epistle II, i, 139–52), ed. J. Butt, 1939, pp. 208–9.

[28] In Lely's Executors' Accounts, B.M., Add. MS 16174, f. 41, the sale is recorded of 'A pannel being posture for the King', another for the Duke of York and another 'of two postures'. Lely owned (see below) a very important group of Van Dyck's small oil studies on panel for the *Iconography*.

[29] B.M., Add. MS 22950, f. 15.

[30] Pepys, *Diary*, 24 March 1666; B. Bathurst, *Letters of Two Queens*, 1922, p. 62, Princess Mary to Frances Apsley, (?)1676: 'I am in great haest to be drest for Mr. Liley will be here at ten of the cloke'.

[31] B.M., Add. MS 22950, f. 3.

[32] Sir G. Isham, 'The Correspondence of David Loggan with Sir Thomas Isham: 2', *Connoisseur*, CV, 1963, p. 91; Arbury MSS, now in County Record Office, Warwick. In the best-known set of portraits by Lely, the *Beauties* at Hampton Court, the draperies and hands are, in contrast with the *Flagmen*, wholly by Lely with the exception of the *Countess of Sunderland*, who is less good in quality than the version at Althorp and whose arms and draperies are in quality very close to Captain Harman's.

[33] Executors' Accounts, op. cit. ff. 20, 14, 8v–9. The catalogue of the sale is published in *Burl. Mag.*, LXXXIII, 1943, pp. 185–91.

[34] A seminal article on dress in portraiture is Diana de Marly, 'The Establishment of Roman Dress in Seventeenth-Century Portraiture', *Burl. Mag.*, CXVII, 1975, pp. 443–51. I am very grateful to Miss de Marly for a discussion on the dress worn by Lely's sitters. For the costumes, which included armour, and material kept in Lely's studio, the reader is referred to Mr. Kirby Talley's article (see Bibliographical note).

[35] 'Booke of Orders . . .', op. cit. II, p. 22.

[36] See E. Walsh and R. Jeffree, *The Excellent Mrs. Mary Beale*, Geffrye Museum and Towner Art Gallery, Eastbourne, 1975–6.

[37] 'Booke of Orders . . .', op. cit. II, f. 198.

[38] J. Douglas Stewart, *Sir Godfrey Kneller*, National Portrait Gallery, 1971, nos. 13, 14, 60.

[39] Houbraken, op. cit.; Graham, op. cit.

[40] Between the early 1650s and the end of his career Lely had raised his price for a head-and-shoulders from £5 to £20 and for a threequarter-length from £10 to £40; in the 1670s he charged £60 for a full-length.

R. North, *The Lives of the Norths*, ed. A. Jessopp, 1890, especially I, pp. 124, 194–5, 392–3, 408–10, and III, pp. 190–209; Lely's will (4 February 1680) is printed in 'Wills from Doctors' Commons', *Camden Society*, 83, 1963, pp. 133–7; Executors' Accounts, op. cit.

[41] *Walpole Society*, XLIII, 1972, pp. 65, 276, 277; MSS in House of Lords, calendared in H.M.C., *7th Report*, part I, 1879, pp. 88–93.

[42] H. Vey and A. Kesting, *Katalog der Niederländischen Gemälde von 1550 bis 1800*, Wallraf-Richartz Museum, Cologne 1967, pp. 65–7.

[43] R.A., *Italian Art and Britain*, 1960, pp. 191–2, nos. 554–99 (notes by A. E. Popham). The value of the prints and drawings as a repository of motifs for Lely himself has not been fully examined; one of his drawings by Parmigianino, sold at Christie's, 11 April 1978 (16), contained the immediate inspiration for his portrait (at Hampton Court) of Princess Isabella.

[44] R. de Piles, *Abrégé de la vie des peintres*, 1699, p. 431. The writer of an anonymous notebook on technique, B.M., Add. MS 22950, records (f. 4) a conversation in 1673 between 'Mr F.' and one of Lely's men. 'Mr F.' said to the journeyman, 'Vandyke hath it not so, says the man go along with me, & he carried him to 2 or 3 pieces of Vandikes & shew him that Variety of colouring in Vandickes Garments'.

[45] Bodleian Library, Rawl. 8° 572, 14 June 1677.

[46] Executors' Accounts, op. cit. ff. 47v, 61v, 68. The epitaph is printed by Buckeridge, op. cit. below.

[47] *Of Dramatic Poesy and other Critical Essays*, ed. G. Watson, 1962, II, p. 21.

[48] H.M.C., *Rutland MSS*, II, 1889, p. 27.

[49] B. Buckeridge, *Essay towards an English-School*, added to English translation (1706) of De Piles, *The Art of Painting*, pp. 445–6; the same note is struck in Walpole's account (*Anecdotes of Painting in England*, ed. R. N. Wornum, 1888, II, pp. 92–3).

[50] Jonathan Richardson, *Essay on the Theory of Painting*, 1715, p. 228.

[51] Petty MSS, v, no. 28 (a reference kindly given to me by Dr Malcolm Rogers).

Colour plate VII *Lady Charlotte Fitzroy, later Countess of Lichfield* (no. 47)

Colour plate VIII *Sir Frescheville Holles and Sir Robert Holmes* (no. 48)

Bibliographical note

There is no up-to-date account of Lely's life and work. In the Introduction and in the entries to the individual items in the exhibition will be found references to a number of printed sources and to the more important manuscript collections in which references to Lely are to be found.

The earliest printed account is by Richard Graham in his *Short Account* of ancient and modern painters included in the English edition (1695) of Du Fresnoy's *De Arte Graphica*. Samuel Cooper and William Dobson are the only other English painters to be included. A slightly later account is by B. Buckeridge, in *Essay towards an English-School*, added to the English translation (1706) of De Piles, *The Art of Painting*, pp. 445–6. In 1719, in vol. II (pp. 33–8) of his *De Groote Schouburgh*, published in Amsterdam, Arnold Houbraken published an important life of Lely; this was to some extent repeated by J. C. Weyerman in his *De Levens-Beschryvigen*, The Hague 1729, II, pp. 142–7. Both authors print the verse eulogy of Lely by Johannes Vollenhove. An important account of Lely's origins and early years, based on contemporary documents, is J. A. C. Ab Wittenaar in *Oude-Holland*, LXVII, part II, Amsterdam 1952, pp. 122–4. Short references appear in Cornelis de Bie, *Het Gulden Cabinet*, Antwerp 1661, p. 385, and in Joachim von Sandrart, *Academie . . . von 1675*, ed. A. R. Peltzer, Munich 1927, pp. 192, 354–5.

An immense amount of information on Lely's works is to be found in the *Notebooks* of George Vertue (*Walpole Society*, XVIII, 1930; XX, 1932; XXII, 1934; XXIV, 1936; XXVI, 1938; index, XXIX, 1947) which were used by Horace Walpole in compiling his account of the artist in the *Anecdotes of Painting*, 1762–71. The edition of 1888, ed. R. N. Wornum, contains (vol. II, pp. 91–101) much material additional to Walpole's original text.

The first serious attempt to evaluate Lely's quality as a painter and to construct his *œuvre* on a chronological basis was made by C. H. Collins Baker in his *Lely and the Stuart Portrait Painters*, 1912. His chronological and stylistic sequence must now be treated with caution; but Collins Baker, who partly wrote from the standpoint of a painter, did so with feeling about Lely's technique and especially about his colour, although, paradoxically, one cannot accept with the same degree of enthusiasm some of the works by which he was particularly moved. In his appendix, vol. II, pp. 132–49, Collins Baker printed some documents relating to Lely. Collins Baker published a shorter work, *Lely and Kneller*, in 1922. R. B. Beckett's *Lely*, 1951, contains a short life of the painter, the largest collection of illustrations to have been published to date and a list of portraits too compressed to be continuously useful. In general the book was written from rather outside the period and made too little use of contemporary sources. Lely's place in the history of British paint-

ing is defined in the most recent standard works, E. K. Waterhouse, *Painting in Britain*, 3rd edn, 1969, and M. Whinney and O. Millar, *English Art 1625–1714*, 1957.

The proliferation of copies, versions and derivations of so many of Lely's pictures would make a *catalogue raisonné*, as opposed to a check-list, a formidable task. Early provenances are difficult to establish from the moment when the contents of the studio were dispersed under the eye of Roger North. A desideratum is the publication of all contemporary or near-contemporary prints after his work. It is, however, a truism that it is only in attempting to complete entries even as cursory as those in this catalogue that one begins to appreciate how much needs to be done if we are to understand the circumstances in which a painter worked or to reconstruct his biography. References in the individual entries will indicate the comparatively few catalogues of collections or exhibitions in which worthwhile notices are to be found.

For Lely's drawings the best accounts are in Croft-Murray and Hulton, pp. 409–24, and in Woodward, pp. 30–5.

Lely's sale catalogue is printed with a good commentary in *Burl. Mag.*, LXXXIII, 1943, pp. 185–91. A good copy of the sale catalogue is preserved at Chatsworth; a later copy, formerly among the Sotheby MSS at Ecton, contained the prices. See also H. & M. Ogden in *Burl. Mag.*, LXXXIV–V, 1944, p. 154, and H.M.C., *15th Report*, Appendix VII, 1898, pp. 179–83. The accounts kept by Lely's executors (B.M., Add. MS 16174) are a very important source. The contents of Lely's studio are to be the subject of an article by M. Kirby Talley which is based on a section of his important (unpublished) PhD thesis, submitted to the University of London in 1977, entitled *Portrait Painting in England: studies in the technical literature before 1700*.

For the commission to Lely to paint portraits for the Medici collections, see A. M. Crinò and O. Millar, 'Sir Peter Lely and the Grand Duke of Tuscany', *Burl. Mag.*, C, 1958, pp. 124–30. The student hardly needs to be told of such lively contemporary sources as the writings of Pepys, Dorothy Osborne and Roger North.

Catalogue notes

The paintings are catalogued in a suggested chronological sequence; the drawings have been grouped in categories – landscapes, working drawings, portrait-heads, the Garter procession. In many cases it has not been possible to re-examine the painting or drawing in the original; measurements are in general those provided by owners and custodians, and are given in centimetres and (in brackets) inches, height before width.

The following abbreviations have been used:

Beckett	R. B. Beckett, *Lely*, 1951
B.M.	British Museum
Burl. Mag.	*Burlington Magazine*
Chaloner Smith	J. Chaloner Smith, *British Mezzotinto Portraits*, 4 vols., 1878–83
Collins Baker	C. H. Collins Baker, *Lely and the Stuart Portrait Painters*, 2 vols., 1912
Croft-Murray and Hulton	E. Croft-Murray and P. Hulton, British Museum, *Catalogue of British Drawings*, vol. I, 1960
H.M.C.	Historical Manuscripts Commission
Lugt	F. Lugt, *Les Marques des collections de dessins et d'estampes*, Amsterdam 1921, Suppl. The Hague 1956
R.A., *Charles II*	*The Age of Charles II*, Royal Academy, 1960–1
Vertue, *Notebooks*	G. Vertue, *Notebooks*, 5 vols.: *Walpole Society*, XVIII, 1930; XX, 1932; XXII, 1934; XXIV, 1936; XXVI, 1938; and index, XXIX, 1947
Waterhouse	E. K. Waterhouse, *Painting in Britain 1530–1790*, 1953; 3rd edn 1969
Whinney and Millar	M. Whinney and O. Millar, *English Art 1625–1714*, 1957
Woodward	J. Woodward, *Tudor and Stuart Drawings*, 1951

Paintings

1 Portrait of a Girl

Canvas, 61 × 48·3 (24 × 19)
Inscribed: *ÆTA. 8/1640*

Formerly attributed to Carel Fabritius, the portrait can be attributed with some confidence to Lely. If the attribution is accepted, the portrait would be his earliest dated work and the only certain portrait from the years before he came to London. It may be suggested that there are already similarities with the portraits from the mid-1640s, such as nos. 2, 3 and 4: tender characterisation, rather superficial drawing, creamy tone in the flesh and strongly marked shadow on the far side of the face. These qualities, with a lack of volume and a tentative placing of the sitter in space within the painted oval, and the pure and individual tone, are suggestive of Gainsborough's earliest Suffolk portraits on this scale.

Private collection

2 Portrait of a Man

Canvas, 102·9 × 77·5 (40½ × 30½)
Inscribed later: *J. Selden*

Provenance: stated to have been purchased by Oxford University as a portrait of John Selden, 1709, but perhaps more likely to have been given by Dr Richard Rawlinson.

Literature: Mrs R. L. Poole, *Catalogue of Portraits in the possession of the University Colleges, City and County of Oxford*, 1, 1912, pp. 48–9; Beckett, no. 475.

The former identification with Selden cannot be sustained by comparison with the certain portraits of him. The sitter is probably Sir George Booth, later 1st Lord Delamere (1622–84). A drawing of this type, based probably on no. 2, is to be found in the interleaved copy of Clarendon's *History* in the library at Chatsworth (vol. III, p. 522). The portrait is there said to be of Sir George and to be in the possession of Thomas Rawlinson (d. 1734), the father of Dr Richard Rawlinson. A copy of the type, inscribed as being a portrait of Sir George, is at Dunham Massey. The rock and landscape in the background of both drawing and copy were also originally to be seen behind the sitter in no. 2, but were painted out at an early date. The outline of the rock can still be discerned. At Dunham Massey there is also a later portrait, by Lely, of a young man who bears no resemblance to the sitter in no. 2, but is also called Sir George Booth. No. 2, painted in the mid-1640s and a fine example of Lely's style at this period, fits better with Booth's age at the time. In the handling of the shadows in the face, the portrait is close to no. 3, which may originally have been a pendant to it.

Lord Delamere, MP for Cheshire between 1645 and 1660, was an active supporter of the Parliamentary

1

cause; but in 1659, having been appointed by the exiled king Commander-in-Chief of all forces in Cheshire, Lancashire and North Wales, he was imprisoned in the Tower.

The Curators of the Bodleian Library, Oxford

3 Portrait of a Lady

Canvas, 91·4 × 76·2 (36 × 30)

Provenance: formerly in the collection of the Earls of Stamford and recorded at Dunham Massey in the inventory of 1769 as a portrait of Sir George Howard's 'Lady: in brown Drapery with a Veil'; passed by descent to Sir John Foley-Grey, sold Christie's 15 June 1928 (59); Viscount Lee of Fareham; Samuel Courtauld; Christabel, Lady Aberconway.

Literature: Beckett, no. 295; D. Cooper, *The Courtauld Collection*, 1954, pp. 182–3 (238); R.A., *Charles II* (22).

The sitter's pretty face, together with the unusually gentle mood and the informal air, led in the 1930s to the identification with Ursula, Lely's 'reputed wife'. She, however, did not come into his life until considerably later. No. 3 belongs stylistically to Lely's earliest years in England and was probably painted no later than *c.* 1647. The sitter probably belongs to the world from which Lely drew the models in his subject-pictures; she is not, for instance, unlike the girl who posed for Susannah in the composition of which three autograph versions survive.

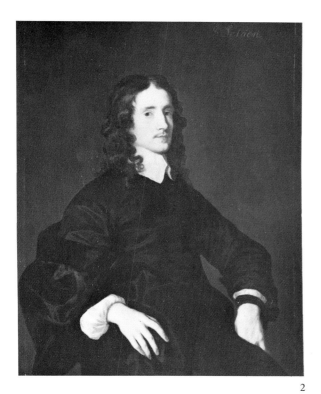

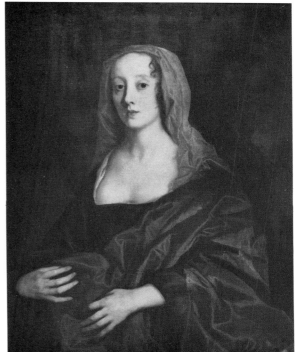

2

3

It is conceivable, on the other hand, that the portrait was originally a pendant to no. 2 in the collection of the Earls of Stamford. Lord Delamere married in 1644, as his second wife, Anne (1622–91), daughter of the 1st Earl of Stamford.

The Hon Dr Anne McLaren

4 Lady Anne Clifford, Countess of Dorset and Pembroke (1590–1676)

Canvas (oval), $74 \cdot 3 \times 62 \cdot 2$ ($29\frac{1}{4} \times 24\frac{1}{2}$)
Inscribed later with the sitter's name and decorated with her arms.

Provenance: among the portraits which descended to the family of the Tuftons, Earls of Thanet, as a result of the marriage of the sitter's daughter (by her first marriage), Lady Margaret Sackville, to the 2nd Earl, and ultimately to his descendant, the 1st Lord Hothfield.

Literature: Abbot Hall Art Gallery, Kendal, *Lady Anne Clifford*, 1976 (32).

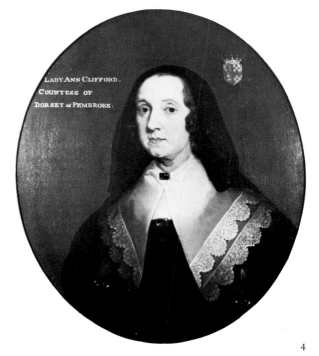

4

Probably the best version extant, and almost certainly the original, of a portrait type which was much copied and distributed especially in the north-west. It is, as a type, normally dated late in the sitter's lifetime; and, on certain versions, dates late in her life are inscribed suggesting that she was happy for it to be regarded as her official portrait although it had been so long out of date. In fact, on grounds of costume, the type must belong to the late 1640s and a version at Dalemain is

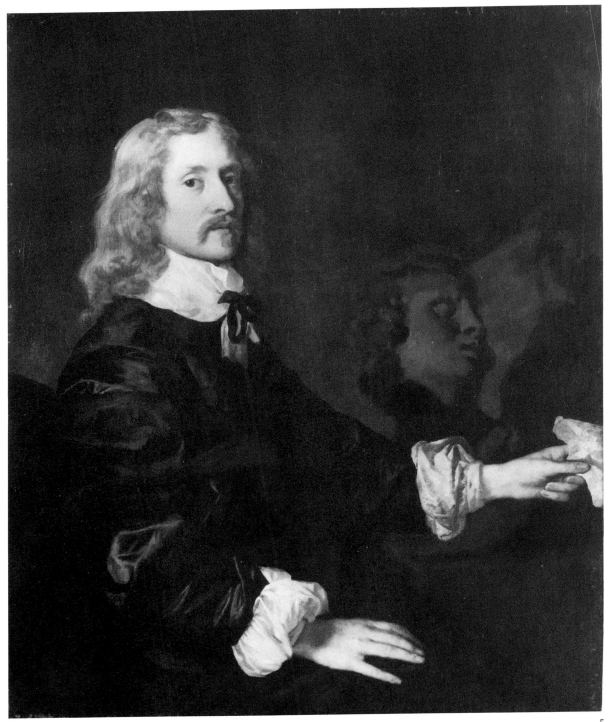

5

dated 1650. In no. 4 the widow's veil may have been painted at a very early date over her own hair. The portrait-type may have originated during the lifetime of her second husband. After his death on 23 January 1650 it became the source of the many derivations, in all of which she appears as a widow. The type must in fact have been produced by 1646 when the triptych or 'Great Picture' at Appleby Castle, in which the full-length of Lady Anne is of the same type, was probably completed. The 'Great Picture' is a later copy, so it is impossible to determine whether the portrait of Lady Anne in it had been painted by, or only based on, Lely (see particularly D. Piper, *Catalogue of Seventeenth-Century Portraits in the National Portrait Gallery 1625–1714*, 1963, pp. 267–8, and Abbot Hall Art Gallery, Kendal, *Lady Anne Clifford*, 1976). Lely was certainly working for the Pembrokes in the late 1640s. A portrait by him of Lady Anne's husband is at Burghley and in clearing the Earl's accounts in 1650 his executors paid Lely £85 'for severall pictures made for the late Earle of Pembrooke' (Hatfield House, Private and Estate MSS, Accounts, 168/2).

Lady Anne, daughter and sole surviving child of the 3rd Earl of Cumberland, did not by the terms of his will succeed on his death to the great family estates in Yorkshire and Westmorland. She married successively the 3rd Earl of Dorset (d. 1624) and the 4th Earl of Pembroke. She finally inherited her estates in 1643, and in 1649 left London to live uninterruptedly in the north-west, devoting herself to rebuilding and repairing the castles and churches on her lands.

Private collection

5 Portrait of a Man

Canvas, 105·4 × 85·1 (41½ × 33½)

Provenance: recorded at Devonshire House in the collection of the 4th Duke (R. and J. Dodsley, *London and its Environs Described*, 1761, II, p. 229).

Literature: Collins Baker, I, p. 97; Beckett, no. 312.

Described since the time of Dodsley (loc. cit.) as a 'Portrait of a Sculptor', but this cannot be sustained merely by the presence of the bust, an attribute common in Lely's portraits. Professor J. D. Stewart has identified the bust as of Eros by Lysippus. It is possible that the sitter is a member of the Boyle or Clifford family and that the portrait may have been among the pictures which came to the Duke of Devonshire on his marriage in 1748 with the heiress of the 3rd Earl of Burlington. Its unusual distinction (a 'romantic quality . . . almost wistful yearning . . .') caused it to be attributed subsequently to Dobson (see Collins Baker, loc. cit.); but it should perhaps be seen as the most accomplished of the group of early portraits (of which no. 2 is a good example) which reveal a restraint and a sensibility which disappeared from

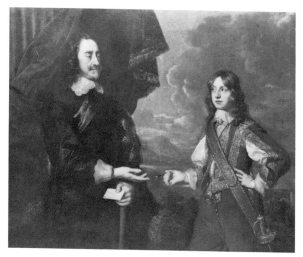

6

Lely's work when he came more directly under the influence of Van Dyck. It should probably be dated *c.* 1646–7.

The Devonshire Collection, Chatsworth: The Trustees of the Chatsworth Settlement

6 Charles I (1600–49) with James, Duke of York (1633–1701)

Canvas, 126·4 × 146·7 (49¾ × 57¾)
Inscribed on the letter held by the king: *Au Roy/ Monsignor*

Provenance: painted for Algernon Percy, 10th Earl of Northumberland; thence by descent.

Literature: Collins Baker, I, pp. 156–7; Beckett, no. 78; Waterhouse, p. 59; Whinney and Millar, pp. 170–1; R.A., *Charles II* (4).

A reported receipt by Lely for payment of £30 to him by Northumberland for this picture does not seem to have survived, but a note of the payment of £20 to Lely by his patron in 1648 ('for the king and the Duke of Yorke's pickture in one peece') is preserved in the MSS at Alnwick Castle (*Burl. Mag.*, XCVII, 1955, pp. 255–6). In the inventory of the pictures at Northumberland House, drawn up by Simon Stone on 30 June 1671, the picture is valued at £20 (MS at Alnwick). Stone ('Mr Stone who Coppyes') had shown the picture to Richard Symonds at Suffolk House on 27 December 1652 (B.M., Egerton MS 1636, f. 92v: 'done at Hampton Court').

The picture records one of the occasions when the king, in custody at Hampton Court, was allowed to see his children (see no. 7) who were in Northumberland's care at Syon; such visits took place, for example, in July 1647 and later in the same year. The two royal

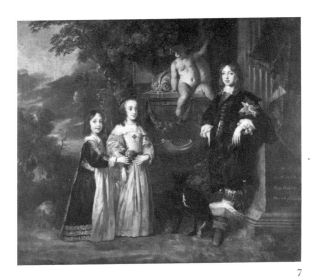

7

groups painted for Northumberland in 1647 are a landmark in Lely's career. They would, perhaps rather ironically, have encouraged him to consider himself already the best, and potentially the most successful, painter in London and, if such a thing was then possible, the successor to Van Dyck. Although there are reminiscences of Van Dyck in nos. 6 and 7, Lely's style is quite distinct from his predecessor's. Much of the detail in the designs is soundly drawn and solidly modelled, but the figures and compositions have nothing of Van Dyck's rhythms. The colour, however, is subtle and individual and the handling impressively direct. Modelling and colour are both richer than in portraits such as no. 2 which were, it is suggested, painted at a slightly earlier period.

No. 6 inspired Richard Lovelace to compose his famous eulogy, '*To my Worthy Friend Mr.* Peter Lilly: *on that excellent Picture of his Majesty, and the Duke of Yorke, drawne by him at* Hampton-Court'. Copies of the design are numerous and there are early copies (i.e. at Syon and Petworth (331)) of the head of the king.

His Grace the Duke of Northumberland, KG, PC, TD, FRS

7 The Children of Charles I: James, Duke of York, Princess Elizabeth (1635–50), and Henry, Duke of Gloucester (1639–60)

Canvas, 198·2 × 233 (78 × 91¾)
Inscribed with the sitters' names and their ages, 14, 12 and 8 respectively.

Provenance: painted for Algernon Percy, 10th Earl of Northumberland; thence by descent (the history of the collections and estate at Petworth is well set out in the current guide-book to Petworth, published by the National Trust).

Literature: Beckett, no. 79; Waterhouse, p. 59; Whinney and Millar, pp. 170–1; R.A., *Charles II* (19).

No. 7 was seen by Richard Symonds at Suffolk House on 27 December 1652: 'The sd. Duke & Princesse Eliz: & Duke of Gloc. a fountayne by. y.ᵐ' (B.M., Egerton MS 1636, f. 92v) and was listed in Stone's inventory of the pictures at Petworth on 3 July 1671 (MS at Alnwick). Northumberland had taken over the care of the king's two youngest children, who were in London, in the spring of 1645. After the fall of Oxford in June 1646, they had been joined by their elder brother. In August 1646 Northumberland took them to Syon in order to avoid the plague and it was while they were there that Lely was commissioned to paint them. A portrait of the Duke of York, closely related to the head in no. 7, and possibly the source from which the head in the group is painted, is signed and dated 1647 (Syon House). A full-length of the Duke of Gloucester, painted by Lely at the same period and possibly given later by Northumberland to Queen Henrietta Maria, is in the royal collection.

The composition is to some extent influenced by, and a sequel to, the group of the king's three eldest

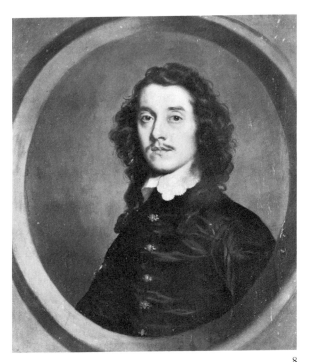

8

children painted by Van Dyck in 1635 (later in Lely's possession), and Van Dyck had introduced into his designs sculptured fountains like the one behind the children; but the fall of light is more dramatic, the paint more richly impasted, the forms more weighty (but much less supple) than in the work of Van Dyck. The background has affinities with Dutch Italianate landscape painting.

HM Treasury and the National Trust (Egremont Collection, Petworth)

8 Portrait of a Young Man

Canvas, 73·7 × 60·3 (29 × 23¾)

Provenance: recorded in the Northumberland inventory of 1847 with an attribution to Cornelius Johnson.

Literature: Collins Baker, I, p. 154, and II, p. 122 (suggesting Charles II as the sitter); Beckett, no. 339 (as Lionel Cranfield, 3rd Earl of Middlesex).

Among the most sensitive of Lely's early portraits, with a wistful 'temper' that accounts for the former attribution to Johnson. The slight uncertainty with which the sitter is placed in the painted oval and the rather flat treatment of the far side of the face point – with the costume – to a date near that of the portraits of the royal children (no. 7). The portrait does not appear to have been among those painted for the 10th Earl of Northumberland.

His Grace the Duke of Northumberland, KG, PC, TD, FRS

9 Lady Lucy Pelham (d.1685)

Canvas, 74·3 × 62·2 (29¼ × 24½)

Provenance: presumably passed to the 1st Lord Yarborough, when he inherited Charles Pelham's estates in 1763.

Daughter of the 2nd Earl of Leicester, sister of Henry Sidney (no. 19). The portrait was probably painted not long after her marriage in January 1648 to Sir John Pelham, 3rd Baronet of Halland. It is a charming example of Lely's portraits in this form, the figure still set rather insecurely in the familiar painted oval: a form which provokes comparison with contemporary portraits in miniature by Samuel Cooper.

The Earl of Yarborough

10 Sir Edward Massey (1619?–74?)

Canvas, 190·6 × 127 (75 × 50)

Provenance: J. F. Basset; G. L. Basset, Tedihy Park; A. F. Basset; Sir Leonard Brassey (1921); acquired by the National Gallery of Canada, 1948.

Literature: Beckett, no. 330; National Gallery of Canada, *Catalogue of Paintings and Sculpture*, ed. R. H. Hubbard, Ottawa and Toronto 1957, I, p. 119 (for earlier references).

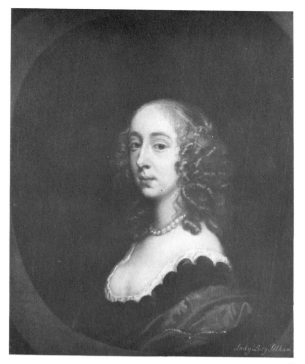

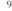

9

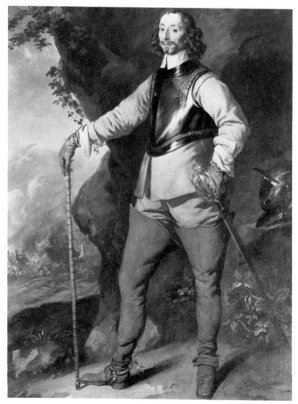

10

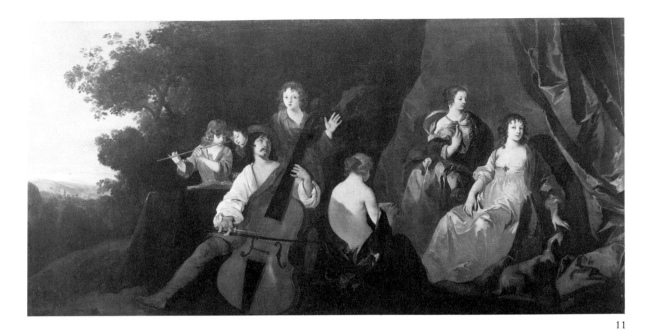

An earlier attribution to Dobson is understandable, but the quality (in such details as the crisp and fluent drawing of the shadows), lively glance, rather uncertain stance and the range of tones are typical of Lely in the later 1640s. Massey, a young Cheshire gentleman, had served in the king's army in the war against the Scots in 1640, but, disapproving of the favours shown to Roman Catholics, had taken a commission from Parliament, for whom he held Gloucester in 1643. A prominent member of the Presbyterian party, he had returned to London in 1646, was a member of the Committee of Safety and was placed in command of the forces raised by the City. Late in the summer of 1647 he escaped to Holland, but returned and late in 1648 was arrested by the leaders of the army.

No. 10, painted at a date close to that of the group of the royal children (no. 7), is probably Lely's first full-length portrait of a non-royal sitter and must have been an important commission. The pattern is influenced by Van Dyck's full-length of Col Thomas Wharton (fig. 5), which Lely could have seen in the collection of Lord Wharton who held the same political and religious beliefs as Edward Massey. A half-length copy is in the Biddulph collection at Rodmarton.

National Gallery of Canada, Ottawa

11 The Concert

(*Cover*)

Canvas, 122·9 × 234·5 (48⅜ × 92¼)

Provenance: possibly acquired by Sir Paul Methuen, whose collection passed on his death in 1757 to his cousin and godson, Paul Methuen (1723–95), in whose house in Grosvenor Street no. 11 was noted (R. and J. Dodsley, *London and its Environs Described,*

1761, III, p. 85: 'A landscape, and a musical conversation, painted by Sir Peter Lely; . . . portraits of himself and his whole family, drawn by the life'); Lord Methuen sale, Christie's 14 May 1920 (23), bought by Lord Lee.

Literature: Beckett, no. 590; P. Murray, *The Lee Collection,* 1958, no. 38 (for earlier references).

The most beautiful and (iconographically) elusive of all the 'Historical Compositions' painted by Lely in London, in this case in the late 1640s. Walpole followed Dodsley (loc. cit.) in thinking the figures were 'Sir Peter's and his family . . . a concert in a landscape' (*Anecdotes of Painting,* ed. R. N. Wornum, 1888, II, p. 97); but, although the figure playing a bass violin (five-stringed cello) is probably the painter himself (see also no. 14), Lely's family did not come into existence until much later in his life. The theme is probably the familiar allegory of Music – the voice, the flute and the bass violin – in the service of Love and Beauty, with reminiscences of the *concert champêtre,* especially in the link between the instrumentalist and the half-naked woman. This figure apparently holds in her hand the music of a song, which is one of the many passages in the design that are almost certainly unfinished. The gesture of the girl with bare breasts silencing a dog recurs at the end of Lely's life in a portrait of Margaret Hughes(?) now in the Tate Gallery.

Courtauld Institute of Art: Lee Collection

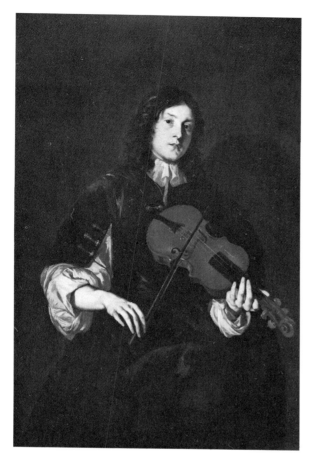

12

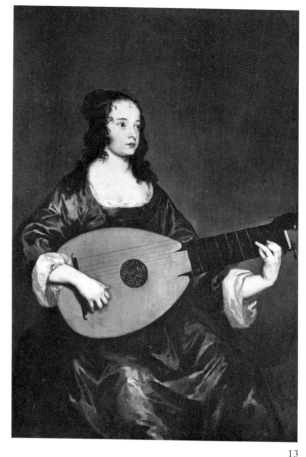

13

12 A Man playing a Violin

Canvas, 142·2 × 93·3 (56 × 36¾)

Provenance: the three portraits of figures playing musical instruments (nos. 12, 13 and 14), and the two from the same set which are now in the Tate Gallery, were formerly in the Craven collection, and were recorded on the staircase next to the billiard room at Coombe Abbey in the inventory of 17 September 1739 (Craven MSS), drawn up at the time of the death of the 3rd Lord Craven: 'Five Italian Musicians by francis Halls'; subsequently noticed by, for example, Horace Walpole in 1768 (*Walpole Society*, XVI, 1928, p. 63, as by 'Francis Halls') and Pennant in 1780 (*The Journey from Chester to London*, 1811, p. 247: 'a capital performance, by *Frank Hals*'); but later attributed to Soest (noted as such by Collins Baker, I, p. 196). The three were sold at Sotheby's, 27 November 1968 (83–85), and exhibited at Leggatt Brothers, *The McDonald Collection*, October–November 1970 (20–22).

The series of five portraits of musicians was probably painted in the late 1640s. The forms are slightly more refined than in the two royal groups (nos. 6 and 7), but the paint is still heavy in texture, the handling very direct and the light powerfully cast upon the figures against dark backgrounds. The four threequarter-lengths were originally presumably uniform in size and nos. 12 and 13 must have been slightly cut down the sides; the pair in the Tate Gallery (T884 and T885), which represent a man playing a recorder and a boy playing a Jew's harp, measure respectively 141 × 104·75 and 141 × 103 (*The Tate Gallery Report*, 1966–67, pp. 16–17). It is perhaps not too fanciful to envisage the four canvases of uniform size hanging on either side of a fireplace, flanking the smaller canvas (no. 14) above it. Lely obviously experienced difficulty, on canvases of this size and shape, in filling the space between the instruments and the bottom of the canvas. Unfortunately no evidence has so far come to light about the commissioning of this unusual series or to connect it with the 1st Earl Craven, who, apart from his own possessions, held pictures in trust from Prince Rupert for his mistress, Margaret Hughes, and their daughter.

Dr D. McDonald

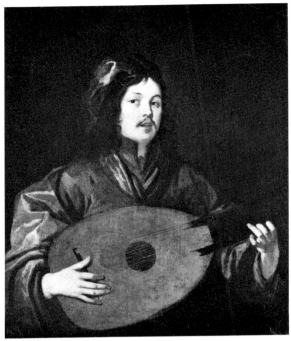

14

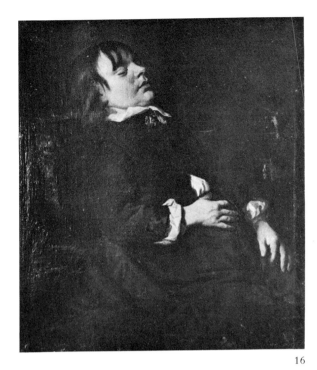

16

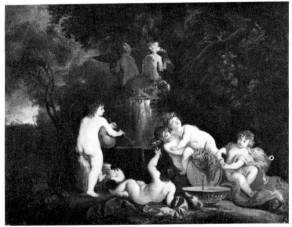

15

13 A Girl playing a Theorbo-Lute

Canvas, 142·2 × 93·3 (56 × 36¾)

See no. 12. The unusual size of the canvas caused Lely drastically to distort the proportions of the sitter, particularly the upper part of her left arm, and to place her in a position in which it is impossible for her to play the instrument she is holding.

Dr D. McDonald

14 A Man playing an eleven-course Lute

Canvas, 109·9 × 88·9 (43¼ × 35)

See no. 12. The sitter is perhaps identical with the musician seated in the foreground of no. 11, and it is not impossible that he is modelled on the painter himself (note particularly the odd formation of the eyebrow) and that the set of musicians' portraits is a record of a circle of friends in the painter's early years in London.

Dr D. McDonald

15 The Infant Bacchus

Canvas, 62·2 × 77·5 (24½ × 30½)
Signed with the monogram *PL*

Provenance: though it is tempting to suggest that this little picture may have been painted by Lely for the Countess of Dysart (no. 23) at the time when he was first working for her, it may have been acquired later. Vertue records (*Notebooks*, II, p. 23) in the sale

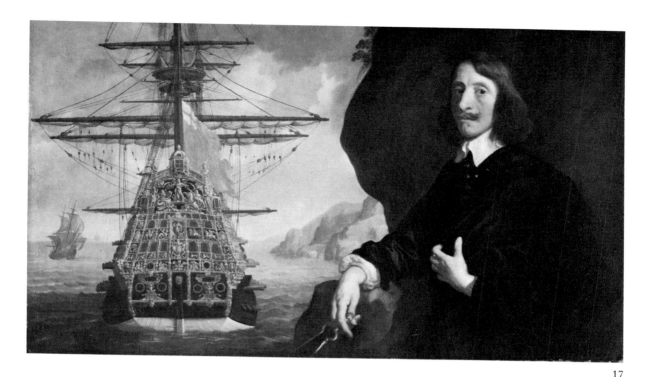

of Mr Collivoe's pictures on 1 February 1727: 'a Curious picture of a Bachanal. of boys naked. 4 Or five one setting on a Tub. the wine running out', on which he noted Lely's monogram.

Literature: Sir E. Waterhouse, *The Collection of Pictures at Helmingham Hall*, 1958, no. 60.

Probably painted in the late 1640s. The slightly Van Dyckian qualities in, for example, the painting of the goat and the draperies are perhaps reminiscent of the subject pictures painted in England by Frans Wouters; but the background is of the individual richness which is so noticeable, on a much larger scale, in the group (no. 7) of the royal children. A copy, oval in form, was sold at Christie's, 22 June 1956 (128).

The Rt Hon Lord Tollemache

16 A sleeping Dwarf

Canvas, 73·7 × 62·2 (29 × 24½)

Formerly described as 'A Boy asleep', but almost certainly a dwarf. A second, and less distinguished, version in the Royal College of Physicians is described as such (D. Piper, *Royal College of Physicians, London: Portraits*, 1964, p. 452). The sitter is almost certainly Richard Gibson; the features agree with the slightly later portrait (no. 18) with his wife, and with a portrait by Lely of 1658, of which there is a copy in the National Portrait Gallery (D. Piper, *Catalogue of Seventeenth-Century Portraits in the National Portrait Gallery 1625–1714*, 1963, p. 138, no. 1975).

No. 16 can be dated in the late 1640s; it has the soft greys and browns, creamy flesh and crisply drawn features and hands of that period in Lely's career. Both subject and treatment are unusual in England at this period and are strikingly Dutch, reminiscent especially of Metsu or Backer.

The Trustee of the Will of the 8th Earl of Berkeley (deceased)

17 Peter Pett (1610–70?) with the 'Sovereign of the Seas'

Canvas, 142·9 × 156·8 (56¼ × 61¾). The upper part of the canvas (c. 50·8) is a later addition; only the original canvas is here reproduced.

Provenance: Sir Richard Worsley, 7th Bt of Apuldercombe (d. 1805), whose property passed to his niece, Countess of Yarborough; Earl of Yarborough sale, Christie's 12 July 1929 (117); acquired from Sir Bruce Ingram for the National Maritime Museum by Sir James Caird.

Literature: G. Callender, *The Portrait of Peter Pett and the Sovereign of the Seas*, 1930; D. Piper, *Catalogue of Seventeenth-Century Portraits in the National Portrait Gallery 1625–1714*, 1963, pp. 273–4.

Peter Pett had been brought up as a shipwright by his father, Phineas, and had built the *Sovereign of the Seas* in 1635–7 under his supervision. He was a commissioner of the Navy from 1660 to 1667, and he owned at Chatham as well as a 'study & Models, with other curiosities belonging to his art', a pretty garden and banqueting house, 'resembling some villa about Rome'

(Evelyn, *Diary* (2 August 1663), ed. E. S. de Beer, 1955, III, p. 359).

The portrait of Pett in no. 17, holding a pair of dividers as a standard symbol of his craft, can confidently be ascribed to Lely and dated *c.* 1650. The tonality, the handling of the whites, the slightly ungainly articulation of the figure, above all the heavy hands, can be paralleled in such portraits as those of Sir Lyonel Tollemache (Holkham Hall) and the so-called 'Sir Henry Vane' in Lady Dysart's series at Ham. It is impossible to accept Callender's attribution (loc. cit.) of the design to the two Van de Veldes: an attribution put forward in Sir Richard Worsley's privately printed *Catalogue Raisonné* (1804) of his collection. A copy (?eighteenth-century, and including the later addition) is in the National Portrait Gallery (no. 1270; see Piper, loc. cit.).

The background, with its prospect of Pett's famous ship, which had been built from the levy of the hated Ship Money ('a glorious Vessel . . . doubtlesse one of the most admirable naval Fabriks, that ever spread Cloth before the wind'), was painted by another and very much cruder hand. The *Sovereign of the Seas*, launched in 1637, had been the most powerful ship afloat of her time; she was lost by fire in 1696. A famous print by John Payne (*c.* 1637) was probably the source of a number of paintings of her. The background could tentatively be ascribed to Isaac Sailmaker, who himself told Vertue that he had as a young man worked for George Geldorp, with whom Lely was also working (*Notebooks*, I, p. 74).

National Maritime Museum, Greenwich

18 Richard Gibson (1615-90) and his Wife

Canvas, 165·2 × 122·1 ($65\frac{1}{6} × 48\frac{1}{6}$)

Provenance: Thomas Herbert, 8th Earl of Pembroke; by him given to Cock, dealer and auctioneer; sold by him to Thomas Gibson (d. 1751), *c.* 1712; Earl Poulett; Sir Berkeley Sheffield, sold Christie's 16 July 1943 (76); ultimately Kimbell Bequest, ACF.44.1.

Literature: Vertue, *Notebooks*, I, p. 31, and IV, pp. 184-5; Beckett, no. 208; Kimbell Art Museum, *Catalogue of the Collection*, 1972, pp. 117-19.

Both Gibson and his wife, Anne Shepherd, whom he married *c.* 1640, were dwarfs, some 46 inches in height. Their marriage was celebrated in Waller's famous lines, 'Of the marriage of the DWARFS. DESIGN, or chance, makes others wive; But nature did this match contrive: . . .' They produced nine children of normal size. In Van der Doort's catalogue of the collections of Charles I there is a reference to the king personally handing a miniature copy by Peter Oliver of Titian's *Venus and Adonis* to 'Dick my Lord Chamberlain's dwarf to copy'. The dwarf may, in the late 1630s, have been in the service of the Lord Chamberlain, the 4th Earl of Pembroke (see no. 4). Anne Shepherd is almost certainly the female dwarf who appears in the portrait at Wilton of Pembroke's daughter-in-law, Lady Mary

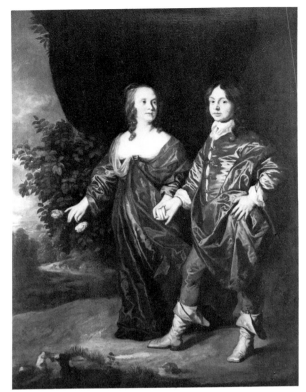

18

Villiers (Earl of Pembroke, *A Catalogue of the Paintings and Drawings . . . at Wilton House*, 1968, no. 163). In no. 18, probably painted *c.* 1650 (the Van Dyckian elements in it are not much more smoothly absorbed than they had been in no. 10), and perhaps for the Pembroke family, the wife's pose is not unrelated to Lady Mary's. Gibson was receiving an annuity from the Pembrokes as late as 1677.

Richard Gibson was chiefly a miniaturist. He was a friend of Lely and it is possible that a small group of miniatures painted in the 1650s by an artist signing with the initials *DG* are by Gibson or a member of his family. They represent, in the main, members of the related Capel and Dormer families who were among Lely's most important patrons at this period.

A drawing of the head of Richard Gibson by George Vertue, based on the same type as no. 18, is in the Huntington Library (R. Wark, *Early British Drawings in the Huntington Collection*, San Marino 1969, p. 57).

Kimbell Art Museum, Fort Worth, Texas

19 Henry Sidney, Earl of Romney (1641-1704)

Canvas, 165·1 × 124·5 (65 × 49)
Signed with the monogram *PL*

Provenance: presumed to have been painted for the sitter's parents, the 2nd Earl and Countess of Leicester; thence by descent.

Literature: Beckett, no. 448; Waterhouse, p. 60; Whinney and Millar, p. 171; R.A., *British Portraits*, 1956–7 (143).

The most beautiful example of Lely's portraits of children in Arcadian costume. He seems to have developed this vein in the service of the Sidney family and their relations in the early 1650s. The Duke of Gloucester (see no. 7) was in the care of the Leicesters at Penshurst between June 1649 and August 1650 and was painted by Lely in the same mood. Moreover the Duke, Henry Sidney and his little cousin Lord Percy (e.g. in a portrait at Petworth, no. 293) are accompanied by the same large setting spaniel which must have belonged to the Sidney or (less likely) the Percy children. Among the pictures given to Henry Sidney by his mother in September 1659 was a portrait of 'Mr. Henry Sidney, halfe body, in an Antique dresse wth a Houlette in his hand. Originall by Lely' (MS at Penshurst), a reference perhaps to the half-length in this convention, almost certainly of the same sitter, at Althorp.

Among the other pictures given to Henry Sidney at the same time was a portrait of his eldest sister, Lady Sunderland, as a shepherdess by Van Dyck (probably the picture still at Penshurst). Van Dyck had painted at least one male full-length – a portrait of Lord d'Aubigny – in Arcadian costume and with an *houlette*; Lely's portraits of 'Noble Persons . . . in pastoral habits' are close to such followers of Van Dyck in this vein as Jan Mytens or Gonzales Coques whose portrait groups (on a small scale) often contain children in this guise. The atmosphere is softer and the colouring more subtle than in the royal group of 1647; and no. 19 is one of the most original and beautiful full-lengths in a landscape painted in England between the death of Van Dyck and the early eighteenth century. It was engraved in mezzotint by Alexander Browne.

At the Restoration court, where he was in the household of the Duke and Duchess of York, Henry Sidney was 'the hansomest youth of his time'. He was later one of the seven who in 1688 invited William of Orange to come to England.

Viscount De L'Isle, VC, KG

20 Portrait of a Girl: 'The Little Girl in Green'

(*Colour plate I, page 8*)

Canvas, 152·4 × 129·5 (60 × 51)

Provenance: see below.

Literature: Collins Baker, I, pp. 159–60, and II, p. 124; Beckett, no. 76.

No. 20 is so close in scale, type and mood to no. 19 that it would be natural to look for the sitter in the Sidney, Percy or Spencer families. She may be one of the two sisters of the 2nd Earl of Sunderland, nieces of Henry Sidney: Lady Dorothy Spencer (1640–70) or Lady Penelope (1642–67). She bears a marked resemblance to a later portrait by Lely of Lady Penelope at Althorp ('A Catalogue of Pictures at

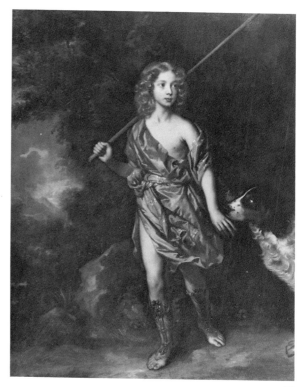

19

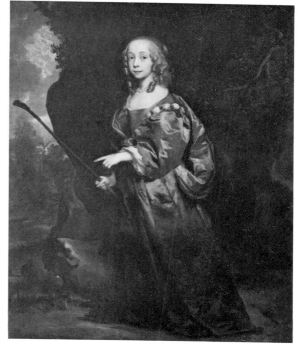

20

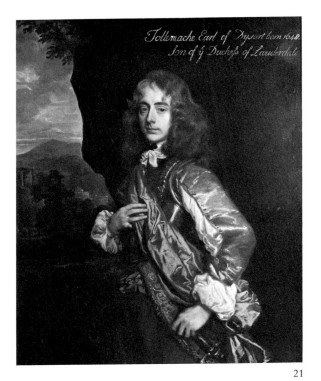

21

Rothes, who became a duke in 1680, held high office in Scotland after the Restoration. His later portraits, as well as confirming the identification of this early likeness, support contemporary opinion that he was virtually illiterate and 'delivered himself without either constraint or decency to all the pleasures of wine and women'.

Victoria and Albert Museum (Ham House)

22 Oliver Cromwell (1599–1658)

Canvas, $77·5 \times 62·9$ ($30\frac{1}{2} \times 24\frac{3}{4}$)
Signed: *PLely. fe* (the initials in monogram) and inscribed: *OLIVER CROMWELL, P.*^{tor}

Provenance: on the engraving by Faber (1735 and 1740) the portrait is said to be in the collection of William Powlett; the print was reissued in 1750 with the owner's name altered to Lord John Cavendish; sold by the Hon J. C. C. Cavendish, Sotheby's 22 June 1949 (46).

Literature: City Art Gallery, Worcester, *Paintings from 1642 to 1651*, 1951, no. 27; Beckett, no. 145; D. Piper, *The English Face*, 1957, p. 115; 'The Contemporary Portraits of Oliver Cromwell', *Walpole Society*, XXXIV, 1958, pp. 31–2, 39–40 (no. 5); City Museum and Art Gallery, Birmingham, *Catalogue of Paintings*, 1960, p. 90.

Presumably painted soon after Cromwell's installation as Protector on 16 December 1653. The pattern became to a limited extent an official image. On 6 October 1654, James Waynwright wrote to John Bradshaw in Copenhagen that he had commissioned for him a portrait of the Protector 'from one Mr Lilly the best artist in England'. He described it as 'a curious picture, exactly done by Mr Lilley, who drew it for his Highness, and hath since drawn it for the Portuguese and Dutch Ambassadors; it cost me 12 l.' (H.M.C., *6th Report*, part 1, 1877, pp. 437b–438a). Many copies of the design are known: for instance, in

Althorp', compiled by K. Garlick, *Walpole Society*, XLV, 1976, no. 393). Lady Dorothy married in 1656 Sir George Savile, later Viscount (and ultimately Marquess of) Halifax; and one of her son's co-heirs was Dorothy, Countess of Burlington, mother of the Duchess of Devonshire (see no. 5).

The Devonshire Collection, Chatsworth: The Trustees of the Chatsworth Settlement

21 John Leslie, 7th Earl and 1st Duke of Rothes (*c.* 1630–81)

Canvas, $124·5 \times 101·6$ (49×40)
Inscribed at a later date: *Tollemache Earl of Dysart born 1648./Son of y^e Duchess of Lauderdale*

Provenance: painted for the Countess of Dysart (see no. 23).

Literature: Beckett, no. 174.

At a later period a number of the portraits which had been painted for Lady Dysart were inscribed with the identities of the sitters. Many of these inscriptions are palpably wrong. No. 21, which was painted in the early 1650s, cannot represent a son who had been born early in 1649, and for whom see no. 58. The 'Estimate' of pictures at Ham (*c.* 1679), however, is a reliable source. No. 77 therein is 'The Duke of Rothe, of S^r Peter Lely'; and comparison with slightly later portraits by, for example, Lely himself (Earl of Haddington collection) and Michael Wright, supports this identification. The young man had been born *c.* 1630,

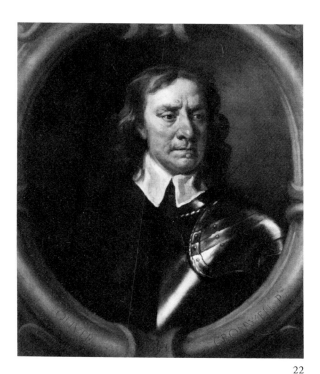

22

Fig. 12 Samuel Cooper, *Oliver Cromwell*. The Duke of Buccleuch and Queensberry

the Pitti, the National Gallery of Ireland, and Sir Danvers Osborn's collection.

It is, however, doubtful whether Lely painted the new Protector *ad vivum*. The image is strikingly close to Samuel Cooper's justly celebrated miniature portrait (fig. 12) which is a much more deeply searching – and very moving – likeness. Lely paints the head with freedom and vigour but has markedly narrowed and lengthened it (and thereby gravely weakened its impact), and given the Protector much more hair. If Lely's image is based on Cooper's – and it is worth remembering that the two artists were near neighbours, Cooper living in Henrietta Street and Lely in Covent Garden – the famous legend in which the painter is instructed by Cromwell to 'paint my picture truly like me. & not Flatter me at all, but . . . remark all these ruffness pimples warts & every thing as you see me', which is first written down by Vertue, *c.* 1720 (*Notebooks*, I, p. 91), should probably be associated with Cooper rather than with Lely (D. Piper, op. cit.).

Birmingham City Museums and Art Gallery

23 Elizabeth Murray, Countess of Dysart (1626?–98)

Canvas, 124·5 × 119·4 (49 × 47)
Inscribed at a later date: *Elizabeth Murray./Countess of Dysart*

Provenance: painted for the sitter and passed by descent (Victoria and Albert Museum, *Ham House*, 1976, pp. 66–72).

Literature: Collins Baker, II, p. 123; Beckett, no. 280.

The countess was one of Lely's most important patrons during the early years of the Commonwealth. One of his most spectacular portraits of this period is a second threequarter-length of her, also at Ham (*Ham House*, op. cit. p. 50). No. 23 illustrates clearly the impact of Van Dyck on Lely. The motif of the page attendant on master or mistress, which is fundamentally Venetian, was often used by Van Dyck, and the probable source of no. 23 is the full-length, now at Kenwood, of Henrietta of Lorraine (fig. 13) which had been in the collection of Charles I and had been sold in 1649. In the case of no. 23, the roses offered to the lady by her negro page may allude to her fertility. The portrait was painted (*c.* 1651) at about the time of the birth of her second son; three more children were to follow. The daughter of the royalist Earl of Dysart, Lady Elizabeth Murray had recently married Sir Lyonel Tollemache. One of the most acute, politically minded and rapacious ladies of her day, she contrived to preserve Ham intact through the Interregnum while keeping in touch with the exiled court and working with the 'Sealed Knot'. At least two of its members were painted for her in the 1650s, and appear in the series of portraits set up by her later in the long gallery at Ham. The frames, made for the pictures in the early 1670s, are exceptionally fine examples of their type, and the long gallery as a whole demonstrates most

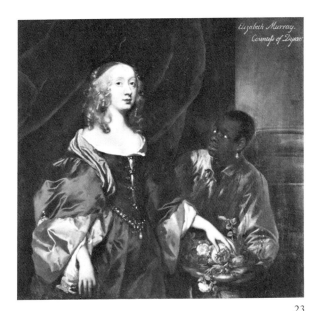

23

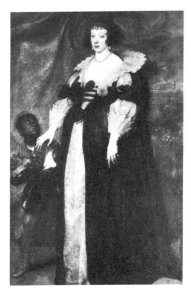

Fig. 13 Sir Anthony van Dyck, *Henrietta of Lorraine*. The Greater London Council as Trustees of the Iveagh Bequest, Kenwood

vividly how such portraits were assembled and displayed by Lely's patrons (*Ham House*, op. cit. pp. 37–40; see also no. 21). The framing of the portraits was undertaken during the lavish rebuilding and redecoration of the house which Elizabeth Murray undertook with her second husband, the Duke of Lauderdale (see no. 37), whom she married, as his second wife, in 1672.

Victoria and Albert Museum (Ham House)

24 The Music Lesson

Canvas, $123 \cdot 2 \times 109 \cdot 9$ ($48\frac{1}{2} \times 43\frac{1}{4}$)
Signed and dated: *PLely/1654* (initials in monogram)

Provenance: sold in the A. A. H. Wykeham sale from Tythrop, Sotheby's 21–22 July 1933 (399).

Literature: Beckett, no. 593; Waterhouse, p. 60; Whinney and Millar, p. 172; R.A., *Charles II* (165).

One of the painter's comparatively few signed and dated works and, on the evidence of style, one of the latest of his surviving subject-pictures. The model for the girl playing the five-course guitar is almost certainly the girl who reappears as Europa (Chatsworth) and the Magdalen (Kingston Lacy and Hampton Court), and she may be the sitter in one of Lely's earlier portrait-drawings (no. 71). The composition and mood are reminiscent of Gabriel Metsu, but the scale and the flutter of draperies are basically Van Dyckian. The playing of a lute or guitar, alone or accompanying the voice, was a favourite pictorial allegory of love and pleasure.

No. 24 may have been painted for the Spiller, Herbert or Dormer families, for whom Lely was working at this period and whose portraits formerly hung at Tythrop. A copy is in the collection of the Earl of Jersey.

The Rt Hon Lord Dulverton, CBE, TD, MA

25 Sleeping Nymphs by a Fountain

(*Colour plate II, page 13*)

Canvas, $128 \cdot 3 \times 144 \cdot 5$ ($50\frac{1}{2} \times 56\frac{7}{8}$)

Provenance: acquired in Paris by Charles Fairfax Murray and presented by him to Dulwich College, 1911.

Literature: Collins Baker, I, p. 139 n.; Beckett, no. 594; R.A., *Charles II* (17); J. Sunderland, *Painting in Britain 1525–1975*, 1976, p. 233.

Probably painted in the early 1650s; the finest of Lely's subject-pictures of this type. There are still obvious reminiscences, though on a much larger scale, of a painter such as Poelenburgh, but the influence of Van Dyck is also felt in the colour and in the face of the sleeping nymph on the left, who bears a resemblance to the sleeping Psyche in Van Dyck's *Cupid and Psyche*, which was for a time in Lely's possession. There is a *pentimento* in the face of the sleeping girl in the centre of the composition which was originally shown complete, but is now partly concealed by the drapery of the dark sleeper on the right. There seems to be no trace of the signature and date 1670 (*sic*) recorded in the Dulwich *Catalogue*, 1926, no. 555. The picture has been rather harshly treated in a recent restoration.

The Governors of Dulwich College Picture Gallery

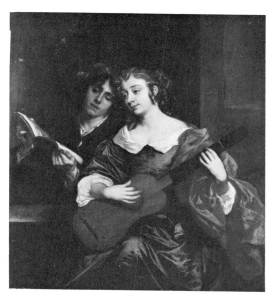

24

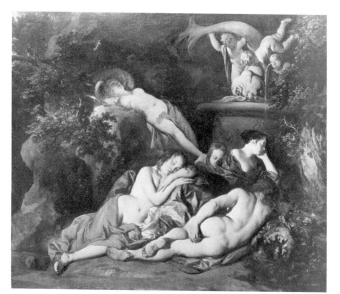

25

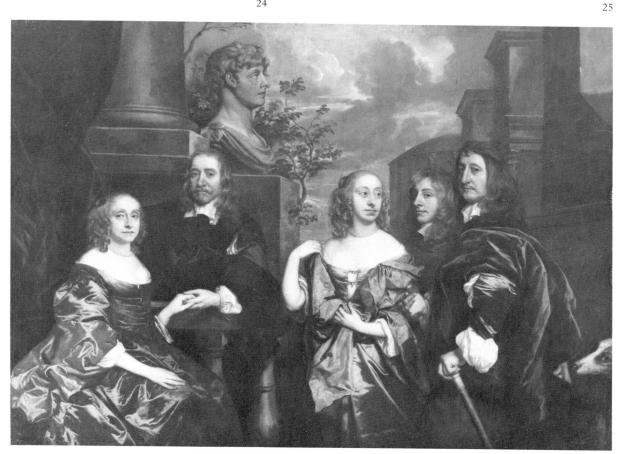

26

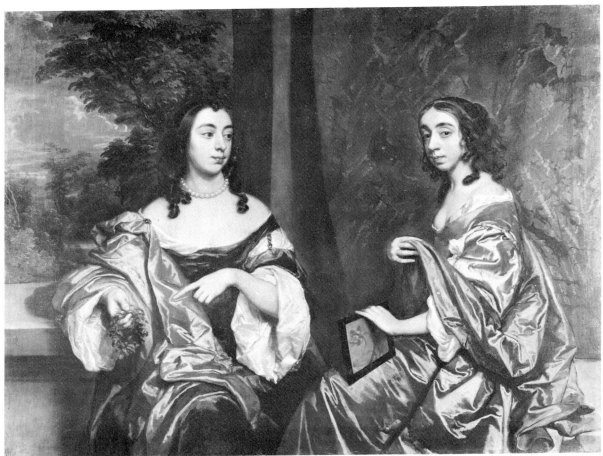

27

26 The Perryer Family

Canvas, 163·8 × 227·4 (64½ × 89½)
Signed and dated: *Peter Lely/A 1655*

Provenance: formerly at Quebec House, East
Dereham, the property of Col E. A. E. Bulwer.

Literature: Collins Baker, I, pp. 162–4, and II,
p. 124; F. Gibson, 'Artistic Treasures at Chequers',
Connoisseur, LVI (1920), p. 17; Prince F. Duleep
Singh, *Portraits in Norfolk Houses*, II, p. 141; Beckett,
no. 418.

No. 26 is one of Lely's comparatively few signed and
dated pieces and the earliest of his life-size family
groups at threequarter-length; but it has not hitherto
been properly examined and little work has been done
on its provenance or on the identity of the sitters. The
badly drawn circular building in the background is
probably intended to represent the Temple of Vesta
in Rome and perhaps alludes to an impending
marriage; the bust may be of the young Marcus
Aurelius. The temple appears, more accurately drawn,
in at least two slightly later portraits of young women
by Michael Wright.

Edward Bulwer of Guestwick (d. 1725) married
Hannah, daughter and heiress of George Peryer of
Godalming. There is much information on the Peryers
(various spellings) in 'The Parish Registers of Godalming',
Surrey Parish Register Society, 11, 1904.

The Administrative Trustees of the Chequers Trust

27 Mary Capel, later Duchess of Beaufort (1630–1715), and her sister Elizabeth, Countess of Carnarvon (1633–78)

Canvas, 130·2 × 170·2 (51¼ × 67)
Signed with the monogram *PL*. On the painting of
flowers held by Lady Carnarvon is inscribed: *E.
Carnarvon/fec . . .* under a coronet.

Provenance: painted for 1st Earl of Essex, see below;
Earl of Essex sale, Knight, Frank & Rutley 12–23
June 1922 (708); with Scott & Fowles, New York,
1925; Jacob Ruppert, 1925–39.

Literature: Vertue, *Notebooks*, IV, p. 17, and V, p. 97;
Beckett, no. 63.

The Capels were among Lely's most important patrons during the Interregnum. He had almost certainly painted Arthur, Lord Capel, in 1647 and he probably began to paint for them again after the marriage in 1653 of Arthur, 2nd Lord Capel (raised to the peerage as Earl of Essex at the Restoration), to Lady Elizabeth Percy, daughter of the Earl of Northumberland. The finest in the set of family portraits painted by Lely were the double portraits of Lord and Lady Capel (now in the Yale Center for British Art) and of these, his two eldest sisters, probably to be dated *c.* 1658. Elizabeth had married in or before 1653 the 2nd Earl of Carnarvon; her sister had first married Lord Beauchamp, who had died in 1654, and in 1657 she married Henry Somerset, Lord Herbert, later 1st Duke of Beaufort. At Cassiobury, the 'very noble Palace' built for Essex after the Restoration by Hugh May (see no. 51), the portraits by Lely were set up in magnificent contemporary frames, which survive on no. 27 and on the single portrait of Henry Capel which is also in the Metropolitan Museum. Vertue (loc. cit.) was greatly impressed by the set of six Lelys which he saw in the Great Library at Cassiobury (including '2 Ladyes setting'). They can be discerned in the same position in Pugin's water-colour drawn for J. Britton's monograph (1837) on the house, and in C. Latham, *In English Homes* (3rd edn 1909), p. 408, where it can be seen that the panelling between bookcases and cornice was divided into recessed panels in which the pictures were to be set.

The richly painted background, the range of strong local colour, fused by Lely's fine sense of tone, and the very direct handling in the draperies, in contrast with the smoother handling of the flesh, are characteristic of his style on the eve of the Restoration, when he has almost come to terms with the elegance he admired in Van Dyck. Lady Carnarvon was a competent flower-painter; there is a small gouache in the royal collection signed in the same way as the little picture she holds (and dated 1662). The Capels loved flowers and gardens. Their brother Henry did much to develop the gardens at Kew, and the Duchess of Beaufort commissioned botanical drawings and developed the gardens at Beaufort House and Badminton. Flowers, and the garden at Little Hadham, are charmingly displayed in Cornelius Johnson's group of the Capel Family before the Civil War (National Portrait Gallery, no. 4759). The wreath of ivy(?) that Mary Capel holds and points to in no. 27 may be an allusion to Poetry.

Metropolitan Museum of Art, New York (*Bequest of Jacob Ruppert, 1939*)

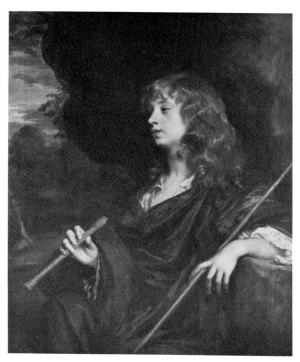

28

28 Portrait of a Boy

(*Colour plate III, page 16*)

Canvas, 91·4 × 75·9 (36 × 29⅞)
Signed with the monogram *PL*

Provenance: recorded by Horace Walpole in the collection of Edward Lovibond at Hampton ('Visits to Country Seats', *Walpole Society*, XVI, 1928, p. 69), and bought by him at the sale of that collection, May 1776; Strawberry Hill sale, 11th day, 6 May 1842 (21), bought by Sir Robert Peel; Peel Heirlooms sale, Robinson & Fisher 10 May 1900 (203); presented to Dulwich College by Charles Fairfax Murray, 1911.

Literature: Collins Baker, II, p. 122; Beckett, no. 129; Horace Walpole, *Correspondence*, ed. W. S. Lewis, XXXII, Yale 1965, pp. 244–5.

The boy with his shepherd's crook and a recorder, painted *c.* 1658–60 and the most romantic and accomplished of all Lely's Arcadian portraits, was for many years identified as Abraham Cowley (born 1618). As a portrait of Cowley it gained a wider circulation through the enamel copy by Zincke, signed and dated 1716, which was the source of a number of engravings and, with the original, belonged to Walpole who gave impetus to its fame. 'The impassioned glow of sentiment, the eyes swimming with youth and tenderness . . .' (*Anecdotes of Painting*, ed. R. N. Wornum,

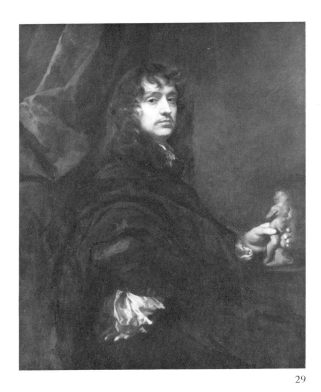

29

1888, III, p. 29). The enamel is now in the Fitz-william Museum. A drawing by Charles Beale of the head from no. 28 is in the British Museum (Croft-Murray and Hulton, p. 183 (127)); and it is perhaps significant that Edward Lovibond, in Walpole's words, had 'several pictures that were Mrs Beale's'.

The Governors of Dulwich College Picture Gallery

29 Portrait of the Artist

Canvas, 108×87.6 ($42\frac{1}{2} \times 34\frac{1}{2}$)
Signed with the monogram *PL*. There are traces of a date(?) below the monogram.

Provenance: from the collection of the Earls of Jersey, hanging at different times at Osterley or Middleton Park. Presumably the picture recorded in the collection of Sir Francis Child, whose eventual heiress, Ann Child, married the 5th Earl of Jersey in 1804. A list of pictures which had been Sir Francis's in 1699 includes (no. 40): 'Sir Peter Lilly, an $\frac{1}{2}$ length, painted by himself' (H.M.C., *8th Report*, part 1, 1881, p. 100b). Sold Sotheby's 4 November 1953 (69); bought by the National Portrait Gallery.

Literature: Collins Baker, I, p. 158, and II, p. 126; Beckett, no. 291; D. Piper, *Catalogue of Seventeenth-Century Portraits in the National Portrait Gallery 1625–1714*, 1963, p. 200 (no. 3897).

Probably painted *c.* 1660; the painter presents himself with the assurance of pose and with the powerful and fluent handling which characterise his portraits at the time of the Restoration. It is, of the surviving self-portraits, the most handsome and the most important before the portrait with Hugh May (no. 51).

A copy on a small scale by Charles Beale, signed and dated 1679, is in the Victoria and Albert Museum (555–1905); a drawing by him after the portrait is in the British Museum (Croft-Murray and Hulton, pp. 183–4 (130)). Another copy in miniature, also probably by Charles Beale, is at Welbeck (R. W. Goulding, 'The Welbeck Abbey Miniatures', *Walpole Society*, IV, 1916, no. 145). It is therefore possible that this is the *Self-portrait* which was in the possession of Charles and Mary Beale as early as 1661, when it was described as a half-length and valued at £20, and which had probably been painted for them (E. Walsh and R. Jeffree, *The Excellent Mrs Mary Beale*, Geffrye Museum and Towner Art Gallery, Eastbourne, 1975–6 (no. 50)). A copy of the head was in a private collection in 1956.

The figurine held in the hand is an attribute familiar in portraits of artists and connoisseurs.

National Portrait Gallery, London

30 The Cotton Family

Canvas, 157.5×223.6 (62×88)
Inscribed later with the identity of the sitters and with the name of the artist and the date 1660.

Provenance: passed by descent after the death in 1863 of the 6th and last Cotton Baronet to Major Affleck King; to his daughter, Mrs Brewis; ultimately to the Rev J. S. Brewis, by whom sold Sotheby's 30 November 1966 (70); bought by the City of Manchester Art Galleries.

Literature: Beckett, no. 128; R.A., *British Portraits*, 1956–7 (146).

The development of Lely's threequarter-length family groups was inevitably influenced by Van Dyck. The awkwardly arranged group of 1655 (no. 26), in which the figures are standing with a very large bust behind them, may contain echoes of Van Dyck's *Family Group* (Detroit Institute of Arts); and the later groups (no. 30 and the slightly earlier group of the Hales family in the Guildhall) are developments, on a grander scale, in a more theatrical setting and in a very different technique, of a design such as the *Family of Endymion Porter* (Mrs Gervas Huxley). Both these Van Dycks belonged to Lely (see E. P. Richardson, 'A Family Group by Van Dyck', *The Art Quarterly*, Detroit, autumn 1953, pp. 229–34). An even closer parallel to Lely's groups of this type are the family groups by Adriaen Hanneman; in particular a group of 1656 in which the relation between figures, landscape and architecture is extremely suggestive of Lely (O. Ter Kuile, *Adriaen Hanneman*, Amsterdam 1976, pp. 94–5 (no. 49)). The date inscribed on no. 30 can be accepted. The canvas has the rich local colour, confident handling and liquid medium of Lely's finest period. The quality, moreover, is sustained right through the design. The contemporary frame is a particularly good example.

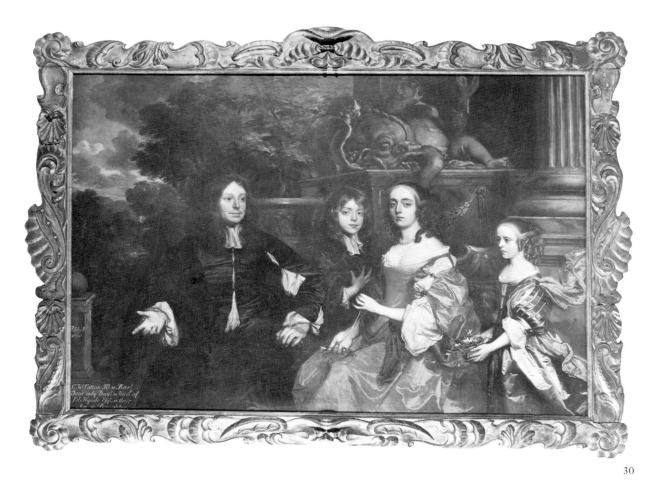

30

Sir John Cotton (1615–89), 1st Baronet of Landwade, had married Jane (1634–92), daughter of Edward Hinde of Madingley Hall. His heir John (born *c.* 1649) died in 1712; his daughter Jane (1648–1707), who in no. 30 is bringing flowers for her mother to bind into a wreath, died unmarried. At the Restoration Sir John, a Cambridgeshire royalist, was appointed Keeper of the King's Game on Newmarket Heath.

City of Manchester Art Galleries

31 Thomas Wriothesley, 4th Earl of Southampton (1607–67), with his third Wife, Lady Frances Seymour (d. 1680/1)

Canvas, 129·5 × 153·7 (51 × 60½)
Inscribed later: *THE COUNTs OF SOUTHAMPTON* and *THOs. EARL OF SOUTHAMPTON*

Provenance: with the other Wriothesley portraits now at Welbeck passed to Lady Elizabeth Noel, a great-granddaughter of the 4th Earl, who married the 1st Duke of Portland. The Wriothesley pictures were removed in 1740 to Bulstrode from Titchfield, where they had been recorded for Vertue in 1731.

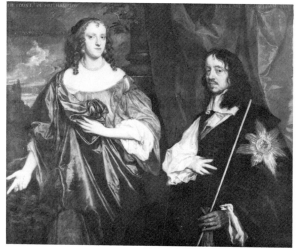

31

Literature: Vertue, *Notebooks*, IV, p. 68, and V, p. 149; Collins Baker, I, p. 166, and II, p. 124; R. W. Goulding 'Wriothesley Portraits', *Walpole Society*, VIII, 1920, p. 70; *Catalogue of the Pictures . . . at Welbeck Abbey . . .*, 1936, no. 363 (strangely, as a copy); Beckett, under no. 500.

The earl, second son of Shakespeare's patron, succeeded his father in 1624. A devoted royalist: 'a great Man in all respects, and brought very much Reputation to the King's cause . . . a Man of great sharpness of Judgement . . . of a nature much inclined to Melancholy'. At the Restoration he was invested with the Garter and appointed Lord Treasurer (8 September 1660); in no. 31 he holds his wand of office in one of his 'pretty thick white short' hands which Pepys admired although he was troubled by their long nails. The earl and Lord Clarendon were conspicuous for refusing to pay court to the king's mistresses. His third wife, whom he had married in 1659, was a daughter of the Duke of Somerset and widow of the 2nd Viscount Molyneux.

No. 31, painted soon after Southampton had received the lord treasurership, is painted in the sumptuous technique of Lely's Restoration manner. The free handling and crisp drawing of the whites in a canvas which is entirely by Lely's own hand contrast strongly with such passages in portraits completed by assistants in his studio. There are numerous copies and derivations of the male figure (see Goulding, loc. cit.).

Private collection

32 James II when Duke of York

Canvas, 182·5 × 143·3 (71$\frac{7}{8}$ × 56$\frac{3}{8}$)
Inscribed: *DVKE OF YORK*

Provenance: painted for the 1st Earl of Clarendon. Nos 32 and 33 were in that half of the Clarendon collection which was secured by the Duchess of Queensbury, daughter of the 4th Earl, passed to the Douglas family and was almost entirely dispersed in the Earl of Home sale, Christie's 20 June 1919 (129, 130); bought for the Scottish National Portrait Gallery (no. 901).

Literature: Beckett, no. 262.

The pair of portraits (nos. 32 and 33) was presumably painted soon after the marriage of the sitters had been made public in December 1660. The duke had fallen in love with Anne Hyde, and contracted an engagement with her on 24 November 1659, when they were in exile and she was a Maid of Honour to the duke's sister, the Princess of Orange. The marriage, which was regarded at first with horror by her father, the Lord Chancellor, and the duke's mother, Queen Henrietta Maria, had been celebrated in secret on 3 September 1660. On learning that his daughter was with child, Clarendon had exclaimed to Ormonde and Southampton (no. 31) 'that he had much rather his daughter should be the Duke's whore than his wife'. The duchess was delivered of a stillborn child on 22

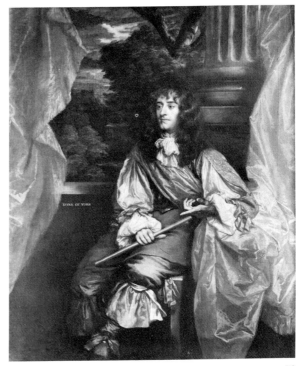

32

October, and the marriage did not prove happy.

The contemporary frames are of the type made for the portraits in Clarendon's collection; and the inscriptions, probably put on in Lely's studio, are in the script found on his pictures. The portraits were probably the most sumptuous contemporary pieces in the collection: magnificently decorative canvases from Lely's most baroque phase, perhaps designed to outshine all but the finest of Clarendon's Van Dycks and much more arresting – and much larger – than the conventional threequarter-length Lely was producing for the chancellor. The gestures of the two sitters may point to a general allusion to Love and War. The two portrait types were combined by Lely at a slightly later date, and perhaps without fresh sittings, in a double portrait of which the finest version is at Petworth (no. 433); there is a replica in the National Portrait Gallery (no. 5077), and a copy at Euston. In a later variant in the royal collection, begun by Lely and completed by Benedetto Gennari, the couple's two daughters were brought into the design. A copy of no. 32 is in the Gorhambury collection; a drawing in the National Gallery of Ireland (no. 2201A, attributed to Caspar Netscher) is probably a record of the figure of the duke in the double portrait. Collins Baker persisted in associating the types with Huysmans, but appears to have been unaware of nos. 32 and 33 (*Catalogue of the Petworth Collection*, 1920, p. 61); in the Northumberland inventory of 1671 the Petworth canvas appears as 'by Lely'.

Scottish National Portrait Gallery

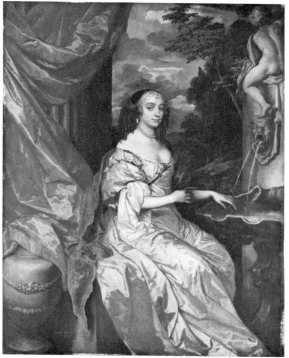

33

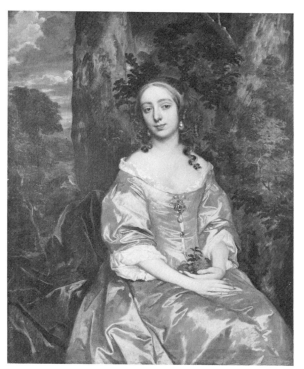

34

33 Anne Hyde, Duchess of York (1637–71)

(*Colour plate IV*, *page 19*)

Canvas, 182·2 × 143·8 (71¾ × 56⅝)
Inscribed: *ANN DVTCHESS OF/YORK*

Provenance: see no. 32. Bought for the Scottish
National Portrait Gallery (no. 1179), 1932.

Literature: Beckett, no. 573.

See no. 32.

Scottish National Portrait Gallery

34 Elizabeth Butler, Countess of Chesterfield (d. 1665)

Canvas, 123·8 × 102·2 (48¾ × 40¼)

Provenance: in the collection of the Earls of
Chesterfield at Bretby; subsequently belonged to
Horace Walpole; sold at Strawberry Hill, 20th day,
17 May 1842 (93), bought by the 5th Earl Stanhope.

Literature: Beckett, no. 90; R.A., *Charles II* (70).

Painted at about the time of her marriage in September
1660 to Philip Stanhope, 2nd Earl of Chesterfield; the
flowers in her lap may be an allusion to her hopes of
issue. She was his second wife and died, aged twenty-
five, in July 1665. The daughter of a devoted royalist,
the Duke of Ormonde, she was 'one of the most
agreeable women in the world . . . a most exquisite
shape though she was not very tall . . . all the expressive
charms of a brunette . . . her heart ever open to tender

sentiments'. Her husband, who had conducted a
passionate affair with Lady Barbara Villiers (no. 44)
before the Restoration, removed her from court in a
fit of jealousy of the Duke of York.

No. 34 contains one of Lely's most richly painted
landscape settings and one of his loveliest passages of
pure colour, in the high key which characterises many
of his portraits in the early Restoration period. A
threequarter-length of Lord Chesterfield, of approxi-
mately the same date, is at Melbourne Hall.

The Administrative Trustees of the Chevening Estate

35 Portrait of a Young Man

Canvas, 126·4 × 101 (49¾ × 39¾)
Signed: *PL* (in monogram) *fecit.*
Inscribed later: *Edward 1.ˢᵗ E. of Sandwich*

Provenance: see below.

Literature: Beckett, no. 363; R.A., *British Portraits*,
1956–7 (147).

If a member of the family of the 1st Earl of Sandwich
is represented, the most likely candidate is perhaps his
second son, Sidney Montagu (*c.* 1648–1727); but the
portrait cannot be much later than *c.* 1662 and is one
of the finest examples of Lely's style at this point in
his career. The handling of the draperies, which are
autograph throughout, should be compared with their
more schematized treatment in, for example, no. 39 or
no. 40.

The Trustees of the Earl of Sandwich's 1943 Settlement

55

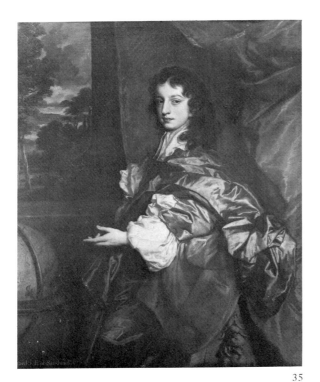

35

36

36 Sir William Temple (1628–99)

Canvas, 76·2 × 61 (30 × 24)

Provenance: passed by descent from Sir William's sister Martha, Lady Giffard; purchased, 1824, by Lord Palmerston in the sale at Moor Park; thence by descent.

Literature: Beckett, no. 531; R.A., *Charles II* (67).

An exceptionally sympathetic and distinguished portrait, painted in the early 1660s, when Lely was at the height of his powers. It became the standard portrait of Temple. There are copies in the National Portrait Gallery (no. 152) and in the Osborn collection and it was often engraved. In the copies the hand is omitted. Threequarter-length derivations are recorded.

Essayist and diplomat, Temple had married Dorothy Osborne late in 1654 at the end of a long courtship during which she had written him a celebrated series of letters, in which there are a number of amusing references to Lely. Temple knew the Low Countries very well and the most important achievement of his career was the Triple Alliance against France in 1668. 'The Presents, made him, in his several Ambassies, were chiefly laid out in Building and Planting, and in purchasing old Statues, and Pictures'. A friend wrote of him: 'his hair a dark brown, and curled naturally, and, whilst that was esteemed a beauty, no body had it in greater perfection; his eyes grey, but lively'.

Private collection

37 John Maitland, Duke of Lauderdale (1616–82)

(*Colour plate V, page 23*)

Canvas, 124·5 × 101·6 (49 × 40)
Inscribed later with the names of artist and sitter.

Provenance: presumed to have been given by the sitter to the Duke of Rothes (no. 21) and to have formed part of his collection of contemporary portraits at Leslie House. The house and many of the portraits were acquired from the Earl of Rothes in 1919 by Sir Robert Spencer-Nairn; sold by Alastair Spencer-Nairn, Christie's 17 November 1967 (100); bought by the Scottish National Portrait Gallery (no. 2128).

One of Lely's most baroque portraits, painted *c.* 1665 and a powerful presentation of a formidable, well-educated, unprincipled and unattractive man. An active Covenanter, Lauderdale had been imprisoned after the battle of Worcester. After the Restoration he was virtually the absolute ruler of Scotland, appointed Lord High Commissioner in 1680. Burnet composed a famous 'character' of him: 'a very ill appearance: he was very big: his hair red, hanging oddly about him: his tongue was too big for his mouth, which made him bedew all that he talked to'. Lely produced at least four main 'types' of him, the latest being the double portrait with his wife (for whom see no. 23) at Ham, the house which remains the chief memorial to their patronage and connoisseurship. In no. 37 the draperies and hands

are splendidly drawn; but, once again, the actual painting of them could have been entrusted to an assistant.

Scottish National Portrait Gallery

38 Queen Catherine of Braganza (1638–1705)

Canvas, 125·1 × 103·5 (49¼ × 40¾)

Provenance: possibly painted for the sitter and probably first recorded in the royal collection in the reign of Queen Anne.

Literature: Colins Baker, II, p. 127; O. Millar, *The Tudor, Stuart and Early Georgian Pictures in the Collection of H.M. The Queen*, 1963, no. 238.

Probably painted *c.* 1663–5; a number of early copies are listed in Millar, loc. cit. There was an unfinished portrait by Lely of the queen in the collection of James II.

Daughter of John IV, King of Portugal, and married to Charles II on 21 May 1662, the queen was compelled to endure many humiliations from the king, in particular the appointment of Lady Castlemaine (no. 45) as Lady of the Bedchamber in August 1662. Short, stout, and devout, with prominent teeth, fine eyes and a waddling gait, she was unable to bear the king a child, and was consistently outshone by his mistresses. She remained in England, living at Somerset House, until 1692; she had earlier filled her bedchamber and closet at Whitehall with 'pretty pious pictures and books of devotion'.

Her Majesty The Queen

39 Humphrey Henchman, Bishop of London (1592–1675)

Canvas, 127 × 104·1 (50 × 41)
Inscribed: *BISHOP HINCHMAN*

Provenance: painted for 1st Earl of Clarendon (see below).

Literature: Beckett, no. 250; R. Gibson, *Catalogue of Portraits in the Collection of the Earl of Clarendon*, 1977, p. 67 (no. 73).

The Earl of Clarendon may have acquired portraits in exile during the Interregnum, but it was between the Restoration and his flight from London in November 1667 that his collection was built up, for the enrichment of Clarendon House. The collection contained portraits of famous men from the time of his youth, celebrated predecessors in the legal profession and, especially, the men he had known and admired during his career – 'the most illustrious of our nation, especially of his Lops time & acquaintance' – who fill the pages of his *History* and *Life*. Evelyn, dining with Lord Cornbury on 20 December 1668 at Clarendon House, described it as 'now bravely furnish'd; especialy with the Pictures of most of our Antient & Modern *Witts*, *Poets*, *Philosophers* famous & learned English-men'.

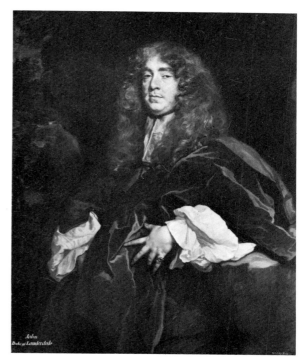

37

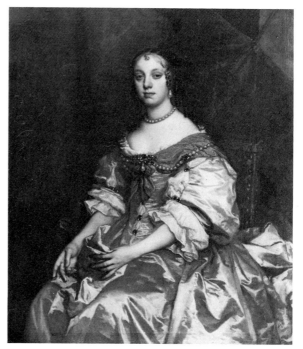

38

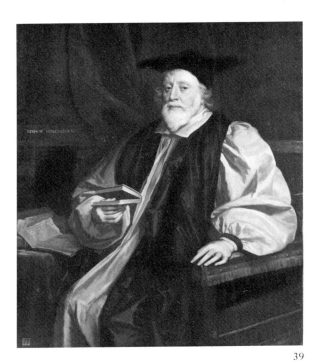

39

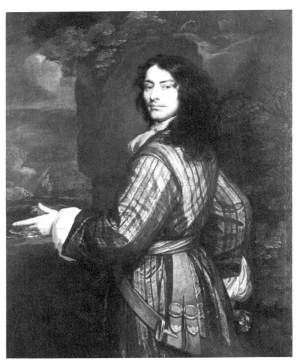

40

Clarendon got hold of a number of originals by Van Dyck, but had to buy or commission copies of standard portraits of many of the sitters he wanted. Some of the copies of earlier portraits were probably done for him in Lely's studio, and he commissioned from Lely a number of portraits of contemporaries. Humphrey Henchman, a devoted royalist who had been deprived during the rebellion and had helped Charles II to escape after the battle of Worcester, was Bishop of Salisbury, 1660–3, and of London from 1663, when he was a commissioner for the repair of St Paul's. Lely, at this excessively busy time in his career, would have had to put assistants on to the chancellor's commissions, but in the best of them, such as no. 39, produced a vigorously painted *ad vivum* head on a threequarter-length canvas; then, as was becoming his practice, he would lay out an appropriate design on the rest of the canvas which an assistant would complete. The handling of the accessories and costume in no. 39, though well drawn, is without the vitality of, for example, the draperies in no. 31. The contemporary frames made for Clarendon and the inscriptions painted on the canvases emphasise the care – and great expense – with which the collection was assembled; its formation is admirably described by R. Gibson (op. cit.). A copy of the head is at Lambeth Palace.

The Earl of Clarendon

40 Sir John Harman (d. 1673)

Canvas, 123·2 × 100·3 (48½ × 39½)
Inscribed slightly later with the sitter's name.

Provenance: painted (see below) for James, Duke of York; eight portraits from the set, including no. 40, were hanging in October 1671 in the Great Chamber at Culford Hall, 'Hung round with green and white silk and thread Damaske'. The set remained in the royal collection until 1824, when it was presented to Greenwich Hospital by George IV (O. Millar, *The Tudor, Stuart and Early Georgian Pictures in the Collection of H.M. The Queen*, 1963, nos. 252, 254).

Literature: Collins Baker, I, pp. 168–71, and II, p. 126; Beckett, no. 245.

The Duke of York commissioned from Lely a series of portraits of the flag-officers who had served under him in the battle of Lowestoft. On 18 April 1666 Pepys saw in the studio 'the heads, some finished and all begun, of the Flaggmen in the late great fight with the Duke of Yorke against the Dutch. The Duke of York hath them done to hang in his chamber, and very finely they are done indeed . . . Captain Harman's'. On 18 July Pepys went with Penn to call on Lely to make an appointment when he could be drawn 'among the other Commanders of Flags'.

Since they were first analysed with extreme enthusiasm by Collins Baker (loc. cit.), the 'Flaggmen' have been given pride of place in assessments of Lely. It is true that in the series Lely's images are, in character and sometimes in design, akin to the portraits by Van der Helst or Maes of the Duke of York's adversaries

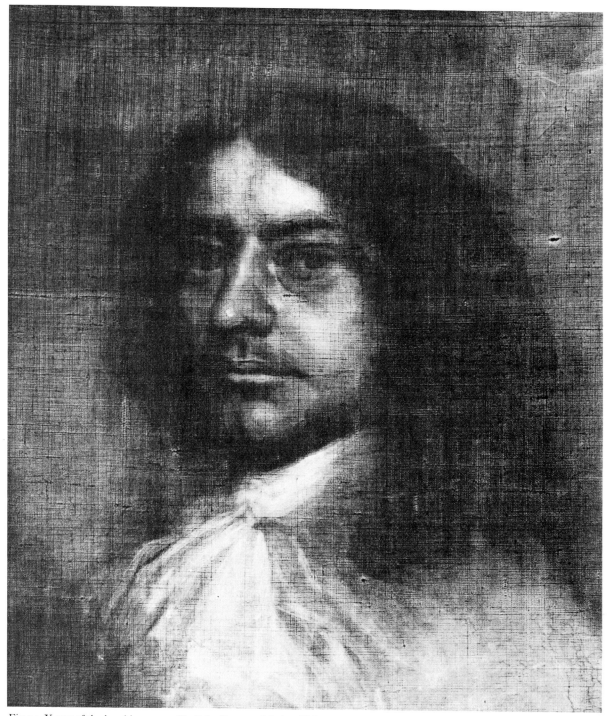

Fig.14 X-ray of the head in no. 40, *Sir John Harman*. National Maritime Museum, Greenwich

and form a powerful contrast with his portraits of the ladies of the court. As Burnet remarked, in words brought forcibly to mind in front of them: 'The Duke found, all the great seamen had a deep tincture from their education: They both hated Popery, and loved liberty: They were men of severe tempers, and kept good discipline'. Nevertheless, the heads which Pepys saw are the only parts of the compositions actually painted by Lely. These heads are among the most powerful he ever painted; but the remainder of the designs are, in the execution, dull; in certain portraits the heads do not grow very convincingly from the shoulders; and the X-ray of no. 40 (fig. 14) shows that the surroundings of the head were radically altered when the design came to be worked out fully. The quality in all but the head does not compare favourably with autograph work of the same date. No. 40 is, however, a particularly arresting pose with its faint echo of Titus in Titian's series of emperors which Lely would have known in the original as well as through the prints by Sadeler. Some of the backgrounds in the set, and some of the hands, are especially bad or dull; the hands in no. 40 are among the best in the series.

Harman, who served throughout the Dutch Wars, had been Captain of the Duke of York's flagship at the battle of Lowestoft. In Martinique in 1667, as Commander-in-Chief, West Indies, he all but annihilated a squadron of French ships.

National Maritime Museum, Greenwich

41 James II when Duke of York

(*Colour plate VI, page 26*)

Canvas, 51·4 × 45·1 (20¼ × 17¾)

Provenance: from the collection of Douglas W. Freshfield (b. 1845) of Wych Cross Place, Forest Row; Sabin Galleries.

No. 41 is valuable as a demonstration of Lely's method and technique. It has clearly been cut from a larger canvas on which only the head had been painted. If Lely followed Van Dyck's practice (and his method is that practised by portrait-painters from his own time to the present day) the sitter would have been shown a rough drawing of a suggested posture (nos. 62, 63 and 64 are examples of this) which might have been lightly drawn on the canvas before sittings began. No. 41 shows the canvas as it would have appeared after the sittings had been completed; thereafter the patron would not have been required to give further sittings and the design would have been completed in the studio. Over underpainting of a terracotta tone (subtly modified in places), the face has been drawn and modelled with considerable subtlety; the hair has been blocked in, but only finished in the area where it curls over the brow; the cravat is merely indicated; the colour of the background is rapidly suggested in dark brown which is also used to clarify the shape of the head. On a small scale precisely the same methods can be seen at this period in unfinished portraits by Samuel Cooper.

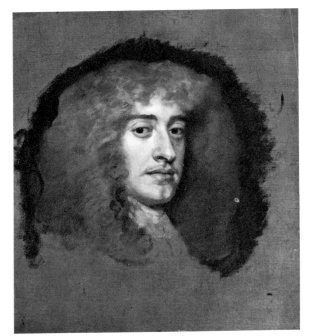

41

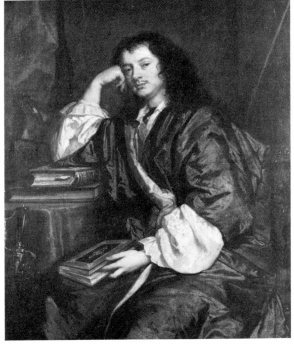

42

This is all that Lely would have felt bound to paint himself under the pressure of his practice, particularly after the Restoration. The shape of the head, outer details of the hair, form of the cravat, and completion of the design would confidently have been entrusted to an assistant. In the portraits of the 'Flaggmen', done for the Duke of York (e.g. no. 40), and in the best of the portraits painted for Clarendon (e.g. no. 39), and in a number of other portraits from this period, one can see clearly the border at which the assistant takes over and across which he attempts to fuse his own handling with that of his master. No. 41 illustrates, in short, what would have confronted Pepys in Lely's studio on 18 April 1666: 'heads, some finished and all begun . . .'. James II later owned two unfinished portraits of himself by Lely (one in armour) and a third described as 'onely dead coloured' (B.M., Harl. MS 1890, f.85v, nos. 1, 6 and 8); two of these are probably to be identified with portraits in the royal collection which have been finished by inferior hands (O. Millar, *The Tudor, Stuart and Early Georgian Pictures in the Collection of H.M. The Queen,* 1963, nos. 239, 240).

National Portrait Gallery, London

42 Thomas, 1st Baron Clifford of Chudleigh (1630–73)

Canvas, 125·7 × 99·1 (49½ × 39)

Provenance: family ownership since painted.

Literature: Beckett, no. 113; R.A., *Charles II* (167).

Probably painted in the later 1660s. Clifford, who had served with distinction at sea, had been appointed successively Comptroller (1666–8) and Treasurer (1668–72) of the Household, and would have carried the white staff shown in the background as holder of either office. It is, of course, possible that the portrait had been painted *c.* 1665 and the staff added slightly later. The informal dress, the pose – reminiscent (in reverse) of Van Dyck's portrait of Thomas Killigrew in the double portrait in the royal collection, the books and the allusions to Clifford's prowess in arms constitute one of Lely's finest designs at this period; although there may be studio assistance in the draperies and accessories. Lely produced a later type for Clifford, between his ennoblement in April 1672 and his death. 'A very fine gentleman . . . valiant, uncorrupt . . . generous, passionate, a most sincere friend'. As a collector of pictures he particularly liked Dutch and Flemish genre painting.

Payments to Lely, and to other painters, are mentioned by C. H. Hartmann (*Clifford of the Cabal,* 1937, pp. 292–3), citing 'Clifford MSS Accounts', which cannot at the moment be found at Ugbrooke.

The Rt Hon Lord Clifford of Chudleigh, OBE, DL

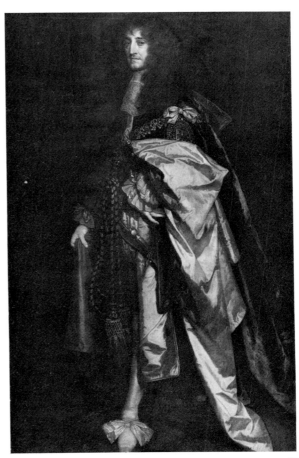

43

43 Prince Rupert (1619–82)

Canvas, 196·9 × 121·9 (77½ × 48)

Provenance: probably in the collection of Henry Bennet, Earl of Arlington, who, among the pictures at Arlington House, owned fifteen full-lengths in gilt frames in a long gallery; however, Prince Rupert and Arlington were on bad terms and no. 43 may have been painted for the Duchess of Cleveland, whose son by Charles II, the 1st Duke of Grafton, married Arlington's daughter and heiress, Isabella. Celia Fiennes noted in 1698 (see no. 52) the display of portraits at Euston.

Literature: Collins Baker, II, p. 128; Beckett, no. 451.

A good example of a standard full-length design for a Garter Knight evolved by Lely in the mid-1660s and in production for some time thereafter. Garter full-lengths are not uncommon in the early Stuart period and Van Dyck had produced at least one; but the marked increase in them after the Restoration was caused no doubt by the revival of the Order and by the new splendour of the Knights' attire, which Lely's own drawings (nos. 86 to 116) illustrate so lavishly. An interesting set of full-lengths of peers in their robes

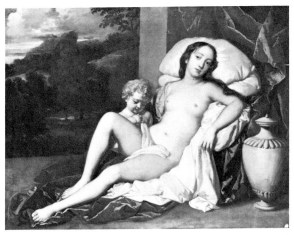

44

was produced by Lely for Sir Allen Apsley and is still at Cirencester Park. Arlington's series appears to have included, with Prince Rupert, the king (no. 52), the Duke of York, and Henry, Duke of Gloucester; the last is a posthumous portrait in which the head is fitted on to the same pattern as Prince Rupert's. Arlington himself, created a Knight of the Garter in June 1672, is shown in a different posture.

In no. 43 only the head is by Lely, an impressive presentation of the prince's sombre, sardonic face. Lely's portrait-types of the prince are confusingly alike, all drawn from the same point of view. The head is almost certainly based on the same type in two three-quarter-length portraits of the prince: the portrait (royal collection) for the Duke of York's set of 'Flagg-men', and a portrait (in the Uffizi) ordered by the Grand Duke of Tuscany in August 1674 and dispatched to Florence in June 1677. The head in a portrait in classical dress (Yale Center for British Art) is slightly different and perhaps younger.

During the Civil Wars the prince had served his uncle, Charles I, with unwearying gallantry and devotion, and after the Restoration proved no less brave and dedicated as naval commander and administrator. Always keenly interested in scientific invention and the arts, he was closely associated with the invention of the mezzotint technique. From 1668 he was Governor and Constable of Windsor Castle, where he fitted up a laboratory and workshop.

The Duke of Grafton

44 Portrait of a Lady and Child as Venus and Cupid

Canvas, 123·2 × 157·5 (48½ × 62)

Provenance: formerly in the collection of the Earls of Lonsdale; Lowther Castle sale, Maple & Co and T. Wyatt, 2nd day, 3rd series, 30 April 1947 (1901), as a portrait of Nell Gwyn; sold Sotheby's 8 February 1950 (76), as the Duchess of Cleveland.

Literature: R.A., *British Portraits*, 1956–7 (157).

The sitter has not been satisfactorily identified. The portrait cannot be linked decisively with the entry (no. 305) in James II's inventory of 1688 for: 'The sliding piece [by Danckerts] before Madam Gwynn's picture naked, with a Cupid' which was apparently later at Buckingham House: 'A naked Lady and son. Lely' (inventory, preserved in the Lord Chamberlain's Office, of 1746). It was the late Mr Denys Bower's conviction that the lady was to be identified with Nell Gwyn, but neither in features nor colouring can this be accepted without considerable reservations (see, for a documented Lely type of Nell Gwyn and a discussion of her iconography, D. Piper, *Catalogue of Seventeenth-Century Portraits in the National Portrait Gallery*, 1963, pp. 148–9). The sitter does, however, bear a considerable likeness to the Duchess of Cleveland, not as she was at the time when no. 45, for example, was painted, but some eight years earlier. The features bear a close resemblance to those in the full-length of the duchess of *c.* 1662, of which the best versions (in England) are at Euston and Knole. In style, however, it is difficult to see no. 44 as painted before *c.* 1665. If the sitter is a (possibly idealised) likeness of Barbara Villiers in the part of Venus, the Cupid may be intended to represent her son by the king, Henry Fitzroy, 1st Duke of Grafton (born 2 September 1663).

Portraits of royal mistresses in the nude had been painted in earlier periods and at other European courts; but ladies of easy virtue had not previously been so unequivocally cast in the role of Venus at the English court. '*Misses* there were, but modestly conceal'd; *White-hall* the naked *Venus* first reveal'd' (Dryden, *Prologue and Epilogue on the Occasion of a Representation for Dryden's Benefit*, 25 March 1700). A full-length of the notorious Lady Cullen without any clothes on was painted in Lely's studio; and Benedetto Gennari's *Danaë*, which belonged to Charles II, strikes much the same note (M. Levey, *Later Italian Pictures in the Collection of H.M. The Queen*, 1964, no. 497).

The Executor of the late Denys Eyre Bower

45 Barbara Villiers, Countess of Castlemaine and Duchess of Cleveland (*c.* 1641–1709)

Canvas, 125·7 × 102·9 (49½ × 40½)

Provenance: painted for Robert Spencer, 2nd Earl of Sunderland (see below); thence by descent.

Literature: Collins Baker, I, p. 127; Beckett, no. 106; R.A., *Charles II* (62); K. Garlick, 'A Catalogue of Pictures at Althorp', *Walpole Society*, XLV, 1976, no. 394.

From the time of the Restoration the beautiful, rapacious and promiscuous duchess repeatedly sat to Lely, who on different occasions painted her as the Magdalen, St Barbara, the Madonna, Minerva and (in this instance) a shepherdess. As one of the most flagrantly sensual women at the court it was appropriate that she should have become the archetype, for Lely as well as in the eyes of posterity, of the Restoration

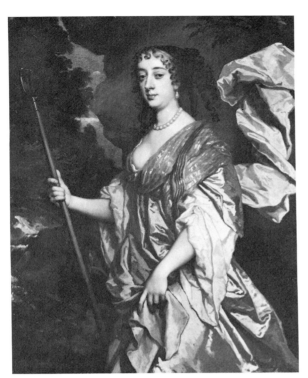

45

payments to Lely by Sunderland in 1666; at least one payment was for a portrait of Mrs Myddelton (information from the late Earl Spencer). The ladies, many of whom had been in Sunderland's house-parties at Althorp, had probably always been intended to hang in the newly panelled gallery, although the pictures in it are not specified in detail before 1746 (Garlick, op. cit. p. 96), when fourteen portraits by Lely were placed in it with, among others, eleven pieces attributed to Van Dyck. The relation between the two painters was nowhere more clearly demonstrated. The length of fluttering drapery in no. 45 is, however, perhaps a reminiscence of one of Northumberland's pictures, a threequarter-length (at Syon) of Mrs Porter. No. 45 can probably be dated *c.* 1670. The handling is still very direct and the paint loaded, but the tonality is acquiring the slightly greyish tone which characterises much of Lely's later work. The hands and draperies, entirely by his own hand, make a significant contrast with comparable passages in pieces in which the studio was employed. It is also perhaps unique among Lely's portraits of the duchess in not having been copied at the time or later.

Many of the Earl of Sunderland's portraits were placed in frames of the type which has come to be called after him; but the design of the so-called 'Sunderland' frames is in fact of a rather earlier date, and can be traced back to combined English and Dutch sources in the 1640s. Sunderland's frames, which can be compared with those made for Lady Dysart at Ham (e.g. nos. 21 and 23), still make a grand impression against the dark panelling of the gallery at Althorp.

Earl Spencer

46 Diana Kirke, Countess of Oxford (d. 1719)

Canvas, 132·1 × 104·1 (52 × 41)
Signed with the monogram *PL*. Inscribed later with the sitter's name.

Provenance: stated to have been bequeathed to Mr Drummond of Great Stanmore by the 1st Duke of St Albans (d. 1726) whose wife, Diana de Vere, was daughter of Lady Oxford; estate of late George Drummond, sold Christie's 6 April 1973 (71).

Daughter of George Kirke, a Groom of the Bedchamber to Charles I, and Mary, daughter of Aurelian Townsend, she married in 1673, as his second wife, Aubrey de Vere, 20th and last Earl of Oxford. On stylistic grounds, however, the portrait should be dated to the later 1660s, when the sitter was his mistress: a period to which the rose and the bare breast would be appropriate.

BSR Ltd

Beauty. A contemporary wrote: 'Sir Peter Lilly when he had painted the Dutchess of Clevelands picture, he put something of Clevelands face as her Languishing Eyes into every one Picture, so that all his pictures had an Air one of another, all the Eyes were Sleepy alike. So that M.^r Walker y.^e Painter swore Lilly's Pictures was all Brothers & Sisters' (B.M., Add. MS 22950, f.41). Thomas Hearne recorded (27 February 1718) a tradition relating to Lely, 'who used to say, that it was beyond the compass of art to give this lady her due, as to her sweetness and exquisite beauty' (*Reliquiæ Hearnianæ*, ed. P. Bliss, 1869, II, pp. 57–8).

Barbara Villiers was typical of the disturbed generation brought up in the Civil War and Interregnum. 'Children asked not blessing of their parents . . . The young women conversed without any circumspection or modesty, and frequently met at taverns and common eatinghouses'. Her father, Lord Grandison, had died of wounds received at the Siege of Bristol. In 1659, after a passionate affair with Lord Chesterfield (see no. 34), she married Roger Palmer, Earl of Castlemaine; but she was established as the king's mistress at the Restoration, bore him at least six children and was created Duchess of Cleveland in 1670.

No. 45 was painted for the Earl of Sunderland, who is thought to have commissioned from Lely, at the time of the rebuilding and redecoration of Althorp in the late 1660s, a set of female portraits which, with the portraits already in his possession, constituted probably the largest collection of Lely's work put together by one patron. In the archives at Blenheim are records of

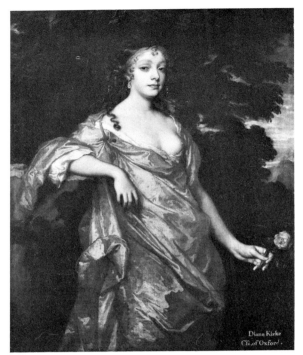

46

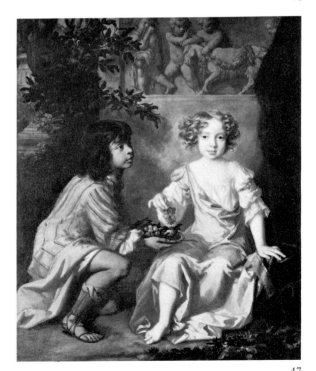

47

47 Lady Charlotte Fitzroy, later Countess of Lichfield (1664–1718)

(*Colour plate VII, page 30*)

Canvas, 127 × 101·6 (50 × 40)

Provenance: passed by descent from the Earls of Lichfield to the 18th Viscount Dillon; sold Sotheby's 24 May 1933 (69), bought Vickers; Sir Bernard Eckstein sale, Sotheby's 8 December 1948 (85), bought Agnew's; presented to York City Art Gallery by the NACF, 1949.

Literature: Beckett, no. 199; Waterhouse, p. 63; City of York Art Gallery, *Catalogue of Paintings*, II, 1963, pp. 58–60 (no. 18); J. D. Stewart in *English Portraits of the Seventeenth and Eighteenth Centuries*, University of California, Los Angeles 1974, pp. 9–11.

Probably painted *c.* 1672. The sitter, later famous for her beauty, sense and virtue, was the daughter of the king by the Duchess of Cleveland. In or before 1674 she was affianced to Sir Edward Lee, later 1st Earl of Lichfield and a staunch Tory. They were married in 1677.

A closely related composition by Lely is engraved by W. Faithorne the Younger with the title of *Beauty's Tribute* and the claim that 'beauty commands submission as its due', even from 'much fairer youths'. Professor Stewart (loc. cit.) identifies the coloured boy as an Indian; points to the connection between the proffered grapes and the Bacchic elements in the relief, in the style of Duquesnoy, which Lely delineates so prominently above the little girl; and links them with the idea of betrothal and marriage which may have prompted the commissioning of the picture by, it may be assumed, Lady Charlotte's mother or father.

York City Art Gallery

48 Sir Frescheville Holles (1641–72) and Sir Robert Holmes (c. 1622–92)

(*Colour plate VIII, page 31*)

Canvas, 134·6 × 163·2 (53 × 64¼). The canvas includes an original addition on the right (*c.* 10.2) and on the top (*c.* 10.8); but the final canvas was later cut on the right (and also perhaps on the left) so that the original inscription is cut: *Sʳ Rob*[. . .]/*Sʳ Frech* [. . .]/*done* [. . .]/*PL* [. . .] (initials in monogram).

Provenance: formerly in the collection of Sir Harold Clayton at Harleyford Manor; sold Christie's from the estate of Lady Clayton, 23 June 1950 (37); bought Agnew's and sold by them to the National Maritime Museum later in the year.

Sir Robert Holmes, 'a very bold and expert man', had distinguished himself as a cornet in Prince Maurice's regiment of horse in the Civil War and later served on land and at sea with Prince Rupert, who had a high opinion of him. His most celebrated achievement during the Dutch Wars came in August 1665, when as Rear-Admiral of the Red and flying his flag in the *Tiger* he led a land and sea force which burned over

one hundred Dutch ships in the Vlie and the town of Westerscheiling: an exploit – 'Holmes's Bonfire' – chosen as one of the actions to be included in the set of paintings which the Duke of York commissioned from the Van de Veldes.

If any event is commemorated in no. 48, in which Holmes is painted with his close friend, Sir Fresche-ville Holles, it is presumably the attack on the home-ward-bound Dutch Smyrna fleet in March 1672. Holmes had been given command of the *St Michael* in January and Holles was captain of the *Cambridge* in his squadron. In May Holles was killed at the battle of Solebay. Stylistically no. 48 could well be dated to this period. It has been suggested that the figure of Holles may have been painted posthumously from an existing image, a theory which gains support from the fact that it was engraved by itself in mezzotint by A. Browne. The source of this plate may have been the portrait of Holles by Lely which was noted by Vertue in the collection of Mr Wright (*Notebooks*, I, p. 97). The handling of the figure of Holles in no. 48 is perhaps less spontaneous than that of his companion, and it may well be that Holmes commissioned the piece after the death of Holles, as a record of their friendship and joint service.

Holles lost an arm in the Four Days' Fight in 1666. Pepys was fascinated by his skill on the bagpipes, but otherwise had an ill opinion of him.

National Maritime Museum, Greenwich

49 Louise Renée de Penancoet de Kéroualle, Duchess of Portsmouth and Aubigny (1649–1734)

Canvas, 121·9 × 101·6 (48 × 40)

Provenance: in the collection of the Earls of Stamford and listed in the Dunham Massey inventory of 1769; later at Enville Hall and sold in the Foley-Grey sale, Christie's 15 June 1928 (48); sold from the collection of Charles Russell, Sotheby's 7 December 1960 (9); bought Agnew's.

Daughter of the Sieur de Kéroualle in Brittany. In 1668 appointed Maid of Honour to the Duchess of Orléans, whom she accompanied to England in 1670. After the death of the duchess she was sent back by Louis XIV to captivate the king and hold him to the French interest. No. 49 was painted soon after she had become the king's mistress; this is alleged to have been achieved in October 1671 at the house-party at Euston which Evelyn describes in a famous passage (*Diary*, ed. E. S. de Beer, 1955, III, pp. 588–92). The French ambassa-dor was also staying in the house with 'the famous new *french* maid of honor' who 'was for the most part in her undresse all day . . . there was fondnesse, & toying, with that young wanton', who gave birth to a son, later created Duke of Richmond and Lennox, in the following July. In 1673 she was created Duchess of Portsmouth.

The design was engraved in mezzotint by Van Somer (Chaloner Smith, III, p. 1420) and one impres-sion gives the date 1679 for the print. No. 49 does not

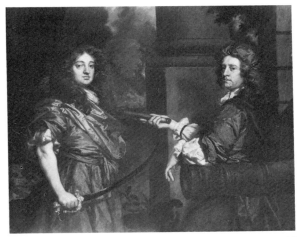

48

appear to have been copied and, with its slightly Frenchified air, is an important example of Lely's style at this date. The head – the 'childish, simple and baby face' which irritated Evelyn – is very close to the type, of which a signed version is at Althorp (Beckett, no. 422), in which the duchess is shown in a landscape as a shepherdess.

The duchess remained the king's mistress until his death, and withdrew to France in 1688.

The J. Paul Getty Museum

50 Heneage Finch, 1st Earl of Nottingham (1621–82)

Canvas, 125·7 × 102·2 (49½ × 40¼)

Provenance: probably given to the sitter's brother-in-law, Sir Edward Dering; bought *c.* 1840 by the Rev Heneage Finch of Oakham from Sir Edward Dering.

Literature: R.A., *Charles II* (143).

Sir Heneage Finch was famous for his 'talent of speaking and expression' and was of great personal service to the king as Solicitor-General (in which office he was prosecuting counsel at the trial of the regicides), Attorney-General, Lord Keeper (from 9 November 1673) and Lord Chancellor (from 19 December 1675). In 1666 he had sat to Lely for a portrait to be hung in Lord Clarendon's collection; but no. 50 was painted later, probably soon after his appointment as Lord Chancellor. The Great Seal is prominently displayed, and no. 50 is one of Lely's most distinguished official portraits of an eminent contem-porary. A copy was painted by Van Diest for Sir Robert Southwell's gallery of portraits at King's Weston; another belongs to Lord Reay.

Private collection

49

51 Portrait of the Artist with Hugh May (1622–84)

Canvas, 143·5 × 182·2 (56½ × 71¾)

Provenance: probably painted for Hugh May; recorded at Billingbear, in the collection of R. A. Neville, who inherited Audley End in 1797.

Literature: Beckett, no. 293; R.A., *Charles II* (219); R. J. B. Walker, *Audley End, Essex, Catalogue of the Pictures in the State Rooms*, 1964, pp. 22–3; D. Green, *Grinling Gibbons*, 1964, pp. 31–2.

Painted, *c.* 1675, to commemorate a long friendship between the two artists (see above, p. 14) and May's appointment by Charles II in November 1673 as Comptroller of the Works at Windsor Castle, where he directed 'the great Alterations made by his Maj^tie. in that castle', an extensive programme of rebuilding and redecoration for the restored king. Allusions to this lie in the plan held in May's lap, the pile of papers on the table beside him and the view of the castle in the distance (the Round Tower and part of the south front). The programme consisted principally of the reconstitution of the upper ward of the castle, in particular the creation of a new range of state apartments on the north side – the Star Building – magnificently enriched by a team of artists and craftsmen under May's command.

Among the artists was the young Grinling Gibbons, and the bust in the background is traditionally said to be a portrait of him. The bust does not, however, bear a completely convincing resemblance to the accepted portraits of Gibbons (see D. Green, loc. cit.). John Evelyn claimed that it was he who had 'first acquainted' Charles II with Gibbons; but an early tradition also maintained that Lely, impressed by work done by Gibbons for Betterton for the Duke's Theatre in Dorset Garden, recommended him to the king. Lely and Gibbons were also associated with May in work carried out for the Earl of Essex at Cassiobury and it was certainly May who gave Gibbons his first important commissions.

The image of Lely himself is probably the original of a type repeated on a head-and-shoulders scale (a good example is at Hampton Court); it is slightly later than the *Self-portrait* acquired for Cosimo III, Grand Duke of Tuscany, in London in 1706 for the famous series of *Self-portraits* in the Uffizi. Antonio Verrio painted himself and May, using Lely's portrait for the head, in the mural illustrating scenes from Christ's miracles on the north wall of the Royal Chapel at Windsor, perhaps the most spectacular apartment in the 'great Alterations'.

Hugh May, who had rendered considerable services to the exiled court during the Commonwealth, was successively Paymaster and Comptroller of the Works. His most important work, apart from Windsor, was at Cornbury House, Eltham Lodge and Cassiobury. Cassiobury and Windsor provided 'the pattern for English baroque decoration'.

The Hon R. H. C. Neville

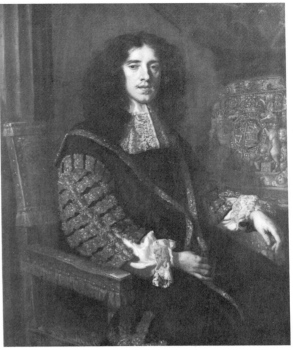

50

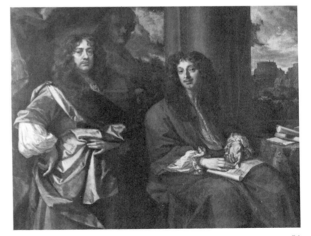

51

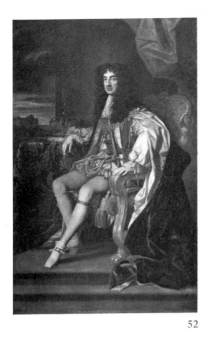
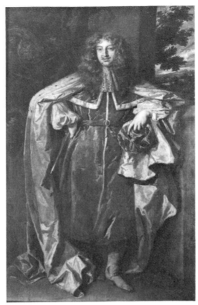
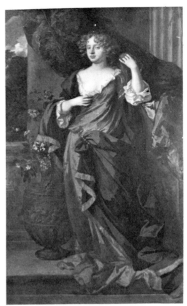

52 53 54

52 Charles II (1630–85)

Canvas, 232·4 × 144·1 (91½ × 56¾)

Provenance: probably one of the portraits seen by
Celia Fiennes in 1698 in the long gallery at Euston, in
the collection of the Duchess of Grafton: 'on the one
side the Royal family from K. Henry the 7ᵗʰ by the
Scottish race his eldest daughter down to the present
King William and his Queen Mary' (*Journeys*, ed.
C. Morris, 1947, p. 150). Perhaps painted for the
Duchess of Cleveland (no. 45), mother of the 1st Duke
of Grafton by Charles II, but more probably passed to
the Duchess of Grafton, daughter and heiress of the
Earl of Arlington, whose pictures at Arlington House
included, in a long gallery, fifteen full-lengths in gilt
frames. One of these was probably no. 43.

Literature: Collins Baker, II, p. 127; Beckett, no. 81;
R.A., *Charles II* (64).

The prime original, of autograph quality throughout, of
a design which was probably produced by Lely *c.* 1675.
A good, but now much damaged, version was com-
missioned in 1677 from Lely by the Governors of the
Bridewell Royal Hospital (sold at Phillips, Son & Neale,
14 November 1977 (127)). A good copy at Ditchley, in-
corporated with other Stuart family portraits into the
decoration of the White Drawing Room, was probably
painted for the king's daughter (by Barbara Villiers),
Charlotte Fitzroy, Countess of Lichfield (no. 47).
Copies are also at Goodwood, Belton, Chelsea Hospital,
and the Town Hall, Winchester, among others; and the
type was engraved by A. Browne, Quiter, R. Tompson,
Allard and the younger Faber. The type was probably
Lely's last official image of the king. It was not, how-
ever, a state portrait in the official sense, because the
king is seen in Garter, and not in state, robes. A tra-

ditional state portrait of Charles II does not, strangely,
appear to have been produced until the last years of the
reign, after Lely's death, by Kneller.

The Duke of Grafton

53 Henry Howard, 6th Duke of Norfolk (1628–84)

Canvas, 224·8 × 134·6 (88½ × 53)
Signed and dated: *P Lely* (initials in monogram)
f/Aº 1677

Provenance: family ownership since painted.

Literature: Collins Baker, II, p. 129; Beckett, no. 384.

Nos. 53 and 54 were painted very soon after Henry
Howard, 'a proud man, and one that values himself
upon his family', had succeeded his brother in the
dukedom in December 1677 and after he had ac-
knowledged his marriage to Jane Bickerton. In 1672 he
had been created Earl of Norwich and hereditary Earl
Marshal; in this portrait he holds the Earl Marshal's
baton. He was the grandson of the great Lord Arundel
and inherited Arundel House and its contents, but was
indifferent to his famous possessions. As a young man
he had rebuilt Albury and redesigned the garden there;
but in 1667 he gave to the Royal Society the library at
Arundel House, apart from the heraldic books and
MSS which he presented to the College of Arms; an
important part of the Arundel Marbles was given to the
University of Oxford; many of those that remained
were sold to the 8th Earl of Pembroke; and Arundel's
collection of drawings was dispersed in an apparently
haphazard fashion. Norfolk himself told Evelyn on
7 May 1683 (an important conversation) that 'Sir Peter
Lely had gotten some of his best'.

The posture of no. 53 was used again by Lely for Lord Cornwallis (Audley End) and for the portrait of a young nobleman (on loan to Marlborough House). The portrait of the new duke was clearly a success. A copy, and a head-and-shoulders variant in a painted oval, are at Arundel. Good versions of the pair are at Corby. The head of the duke was used by Jan Wyck in a large equestrian portrait, signed and dated 1677, at Drayton and in a smaller equestrian portrait at Arundel. The head was engraved by Blooteling in 1678. For Lely's preliminary study, see no. 64.

The pair provide an excellent illustration of Lely's late manner, with its deep, fused tones and dark underpaint; the rough, free, but rather dry, handling; the pervading warm greyish note.

His Grace the Duke of Norfolk, CB, CBE, MC

54 Jane Bickerton, Duchess of Norfolk
(*c.* 1644–93)

Canvas, 224·2 × 134 (88¼ × 52¾)
Signed and dated: *P Lely* (initials in monogram)
*fe*ᵗ. A 167[7]

Literature: Collins Baker, II, p. 129; Beckett, no. 385; Whinney and Millar, pp. 175–6.

Norfolk had told Evelyn in 1671 that, 'though he kept that idle Creature & common – Mrs. B – ' and would leave £200 a year to his son by her, he had no intention of marrying her and that the king had warned him against it. Evelyn draws a sad picture of the 'base, & vicious Courses' into which Norfolk had lapsed after the death of his first wife, Lady Anne Somerset, in 1662. Jane Bickerton was a daughter of a Gentleman of the King's Wine Cellar; she finally married the duke, probably shortly before 23 January 1677–8.

The pattern is one used for, or chosen by, a number of Lely's clients in the last years of his life and turned

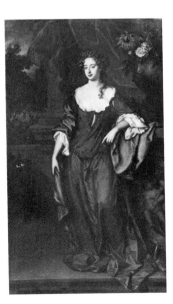

Fig. 15 Willem Wissing, *Jane, Lady Hoskyns.* Sir Benedict Hoskyns, Bt

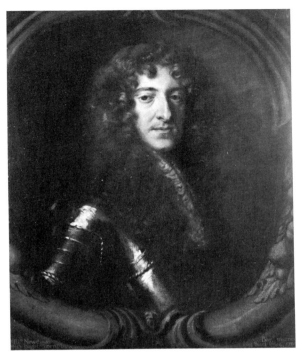

55

out with only slight variations for (for example) the Duchess of Cleveland (the best versions perhaps at Ditchley and Aske), Lady Cornwallis (Audley End), Mary of Modena (royal collection) and Lady Newdegate (Arbury). The elements in the design can, of course, be traced back to Van Dyck; but the formal arrangement, the elaborate stagecraft and the simplified construction of the draperies set the pattern for formal portraiture of this kind for the next fifteen years or so in England as practised by Riley, Wissing (fig. 15) and, in his earlier years in London, Kneller, though none of them could produce the rich sense of atmosphere that distinguishes Lely in this vein. There is a parallel between these female portraits by Lely, with their mannered pose and elongated figure, and female figures by his friend Grinling Gibbons: on, for example, the Campden monument at Exton or the Beaufort monument at Badminton (D. Green, *Grinling Gibbons,* 1964, figs. 210–11, 237). The flowers in no. 54 were clearly painted by a specialist assistant.

His Grace the Duke of Norfolk, CB, CBE, MC

55 Sir Richard Newdegate (1644–1710)

Canvas, 76·8 × 64·1 (30¼ × 25¼)

Provenance: family ownership since painted.

Literature: Collins Baker, II, p. 128; Beckett, no. 379; R.A., *Charles II* (367).

A very late work and an admirable example of Lely's technique at this period, the drawing crisp and fluent, the impasto vigorous and free: a technique, in short,

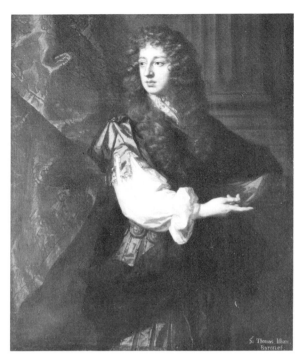

56

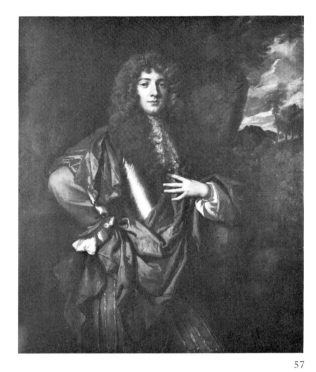

57

which no imitator could emulate and which sets a standard by which Lely's work should be judged. The MSS at Arbury (now in the County Record Office, Warwick) contain important documents concerning Lely and his work for the family (some inaccurately printed in Lady Newdigate-Newdegate, *Cavalier and Puritan*, 1901, pp. 118–19, 204–5). They include a letter in Lely's hand, dated 11 March 1678, addressed to Sir Richard: 'I beg, your pardon that I have not sent yours, and your Ladys picture yett – The Reason, is because I Intend to send my Lord Mazarine's [Massereene] wch will be done wthin three weekes, by wch time you may please to give the Carrior order to Call for them . . .' (C.R. 136/B580). Sir Richard recorded in his diary for 12 June 1680 that he called on Lely to whom he owed £100, which included £20 'for my own wch my wife earnestly desird'.

A hot-tempered and extravagant character, an ardent Protestant and MP for Warwickshire, Sir Richard succeeded to the baronetcy in October 1678. He was a patron of Gibbons, whom he commissioned to make the monument in Harefield church to his wife (d. 1693; D. Green, *Grinling Gibbons*, 1964, p. 160). The traditional painted oval, which Lely had used throughout his career on a number of occasions for canvases of this size, takes on a richly sculpted baroque character towards the end of his life; the form was often imitated by Mary Beale.

The Trustees of the Newdegate Settlement

56 Sir Thomas Isham (1657–81)

Canvas, 123·2 × 100·3 (48½ × 39½)
There are possible traces of a signature: *P L*.
Inscribed slightly later with the sitter's name.

Provenance: painted for the sitter for presentation to Robert Spencer, Lord Teviot; passed to the 3rd Duke of Marlborough, but later given to Dr Edmund Isham (d. 1817); passed to his nephew, the Rev Euseby Isham, and bought at his death by Sir Charles Isham.

Literature: Beckett, no. 261; Sir G. Isham, 'The Correspondence of David Loggan with Sir Thomas Isham: 2', *Connoisseur*, CV, 1963, pp. 84–91.

Sir Thomas Isham succeeded his father, the 2nd Baronet, in 1675 when he was an undergraduate at Christ Church. Between October 1676 and August 1679 he was abroad; and in Italy he acquired, in addition to prints and books, an interesting group of pictures which survives, well documented and lovingly maintained, at Lamport Hall (see G. Burdon, 'Sir Thomas Isham An English Collector in Rome in 1677–8', *Italian Studies*, XV, 1960, pp. 1–25, and an exhibition of his collections, Central Art Gallery, Northampton, 1969). In Rome Sir Thomas sat to Maratti and Ferdinand Voet. His 'Grand Tour' is significant for the increasing importance of such travels in stimulating a knowledge in this country of the arts of Italy.

Sir Thomas had sat to Lely some months before his departure from England: the portrait may have been completed in January 1676 and Loggan paid Lely £20, on the baronet's behalf, in or before May. Sir Gyles

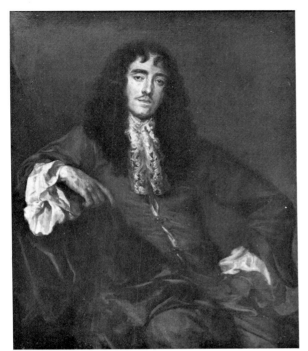

58

Isham (loc. cit.) associated this sitting and payment with the less distinguished version of no. 56 (which is also at Lamport) and showed that no. 56 was painted with special care by Lely after the sitter's return from Italy. 'You desir to have ye head and ye cravat of your picture changed and ye face of yᵉ picture putt on it which Master Lilly has drawn for you since you came over reserving ye same posture, nor altering any of ye colours'. Clement Saunders, writing to Sir Thomas on 13 December 1679, describes the portrait, which he had just seen in Lely's studio, as 'extreame like and very well done, Mr. Lilly says he will make it one of the best peeces hee ever did'.

Nos. 56 and 57 are good examples of the patterns which Lely coined at the end of his career. In costume, technique and posture they emphasise the extent of Lely's influence on painters of the next generation, especially Wissing, Riley, and Kneller in the 1680s – to say nothing of Lely's own less well-known followers. Lely himself used the design of no. 56 for Sir Ralph Verney (Claydon) and Lord Ogle; and a portrait of Charles II is set in the same mould (Christie's 14 July 1950 (109)). The portrait of Isham was engraved in mezzotint by Loggan, which would have made the design available to such imitators as Mary Beale who copied the portrait of Lord Ogle and used the pose for Henry Coventry and the 2nd Lord Downe, though without the air and authority which Lely can command. It is noticeable that only in no. 56, among all instances of this pattern, are the sitter's eyes directed away from the spectator.

The Directors of Lamport Hall Preservation Trust Ltd

57 Sir Thomas Grosvenor (1655–1700)

Canvas, 120·7 × 101·6 (47½ × 40)
Signed and dated: *PLely* (initials in monogram)/
AP:/1678/8

Provenance: family ownership since painted.

Sir Thomas, who had succeeded his grandfather, the 2nd Baronet, in 1664, was MP for Chester, and in 1677 married Mary Davies, daughter and heiress of Alexander Davies of Ebury, a match which brought into the family the enormous Grosvenor estate in Westminster: 70 acres south of Oxford Street between Bond Street and Marble Arch, and 360 acres between Knightsbridge and the river. Sir Thomas's son, the 4th Baronet, began to plan the original development in Mayfair with Grosvenor Square at its heart. At the period of his marriage William Samwell was building Eaton Hall for the baronet. See no. 56. A contemporary copy of no. 57 is at Chirk Castle; the sitter's mother was a daughter of Sir Thomas Myddelton of Chirk.

The Executors of the 4th Duke of Westminster (deceased)

58 Lionel Tollemache, 3rd Earl of Dysart (1649–1727)

Canvas, 104·1 × 87·6 (41 × 34½)

Provenance: the sitter married in 1680 Grace, daughter and co-heiresss of Sir Thomas Wilbraham; her sister married the 1st Earl of Bradford.

The informality and the odd slumped pose are unusual in Lely's work. It is one of his most arresting and unconventional paintings, comparable, perhaps, with Kneller's portrait of 1685 of the 3rd Earl of Leicester (Waterhouse, pl. 84 (A)) in its foreshadowing of the eighteenth century. However, it was probably not finished by Lely. The left hand and the lower part of the body seem misunderstood (as well as partly unfinished) in contrast with the fine handling of the right sleeve and the hand.

Son of the Duchess of Lauderdale (no. 23), whom he succeeded in the earldom of Dysart in 1698, the sitter inherited an encumbered estate. A naturally prudent temperament became one of downright stinginess.

The Rt Hon the Earl of Bradford

59 Roger North (1653–1734)

Canvas, 76·8 × 63·5 (30¼ × 25)

Provenance: family ownership since painted.

Literature: Collins Baker, II, p. 130; Beckett, no. 388; R.A., *Charles II* (181).

Among Lely's latest works, engraved by Vertue in 1740 as painted in 1680. A copy is in the National Portrait Gallery (no. 760). Intelligent, idiosyncratic, a lawyer by profession, North was a distinguished historian, an amateur yachtsman, an ardent lover of music (see *Roger North on Music*, ed. J. Wilson, 1959), and a keen student and collector of pictures. His *Lives* of his brothers (first published 1740–4) provide a vivid and

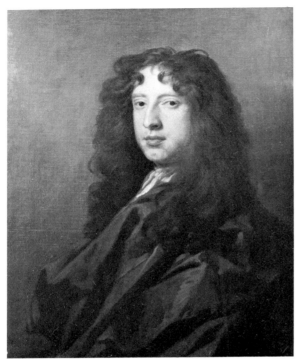

59

absorbing picture of the tastes and attitudes of men of his class. The eldest brother, the Earl of Guildford, the Lord Keeper, gave Lely professional legal advice on his affairs; and Roger North became Lely's executor and arranged the sale of his collection of pictures and drawings after his death. Chapter xv of his *Auto-biography* is devoted to 'The Affairs of Sir Peter Lely' (the most convenient edition of both works is that by A. Jessopp, 3 vols., 1890). In return for Guildford's help with his affairs, Lely, 'averse to business, and loathly drawn to do anything but paint', gave him 'excellent portraits of him and his relations, which are still extant and of great value'.

Roger North, Esq

Drawings

60 Landscape with Small Figures

Grey wash with some ink(?) on paper, $15 \cdot 5 \times 21$ $(6\frac{1}{8} \times 8\frac{1}{4})$
Signed and dated: *P Lelÿ 1643* (initials in monogram)

Provenance: G. Knapton (1807); W. Esdaile; sold Sotheby's 16 January 1958 (189).

Private collection

61 Landscape with a Church and a distant Windmill

Pencil with pink and grey wash, $11 \cdot 2 \times 28 \cdot 1$ $(4\frac{7}{16} \times 11\frac{1}{16})$; a possibly slightly later margin ruled in sepia ink.
Signed and dated: *P Lely* (initials in monogram)

Provenance: Earl of Malmesbury; acquired by Birmingham City Museums and Art Gallery, 1950.

The two drawings of landscape appear to be the only drawings by Lely which may have been executed before he arrived in London. A drawing in pen and wash of a company in an interior, which is signed with a monogram *PL* and dated 1639 (Croft-Murray and Hulton, p. 407), cannot convincingly be attributed to Lely.

No. 60 is slightly reminiscent of certain Dutch Italianate painters; the second drawing, more precisely topographical in design, is perhaps nearer the work of the Haarlem artist Jan van de Velde II.

Birmingham City Museums and Art Gallery

62 Study for a Seated Male Figure

Red, black and white chalk, with an area of grey and dark brown oil paint, on grey-brown paper, $38 \cdot 5 \times 25 \cdot 5$ ($15\frac{3}{16} \times 10\frac{1}{16}$)

Provenance: in the artist's sale (Lugt, 2092); T. Hudson (Lugt, 2432); Prince Wladimir Argoutinsky-Dolgoroukoff (Lugt, 2602d), sale, Amsterdam, 9 April 1925 (182); F. Lugt (Lugt, 1028); Fondation Custodia, no. 2146.

Lely's practice in designing a portrait was first to sketch the posture in chalk, partly for submission to the patron and following the example of Van Dyck. 'Little

60

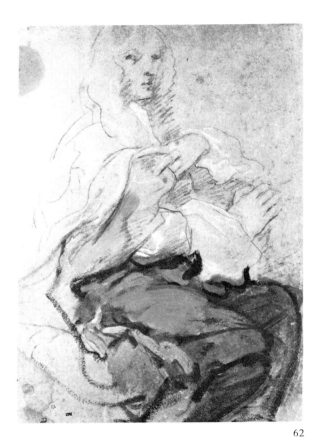

62

Lely was a more prolific draughtsman, and made more preparatory studies in the course of his practice, than any other professional portrait-painter in London between Van Dyck and Allan Ramsay. He did not, however, make large preparatory drawings from life of the heads of his sitters, in the manner of, for example, Dahl or Lawrence. Drawings play the same role in his practice and methods as in Van Dyck's.

Fondation Custodia (Coll F. Lugt), Institut Néerlandais, Paris

63 Study for a Seated Female Portrait

Black and red chalk, heightened with white, on grey paper, 39·2 × 29·5 (15 $\frac{7}{16}$ × 11 $\frac{5}{8}$)

Provenance: in the artist's sale (Lugt, 2092); Sir Thomas Lawrence(?); his great-nephew, Matthew Holbeche Bloxam (1805–88).

A study for a portrait of *c.* 1665; and a good example of the type of drawing by which a design could be submitted to a patron. In the general disposition of costume, arms and hands the drawing is preparatory to a threequarter-length design used for Lady Elizabeth Carey (Earl of Roden), the Countess of Sunderland (Althorp) and Miss Brown, a studio piece (Hagley). In all three the dress has been enriched with pearls and more luxuriant draperies.

Rugby School

64 Study for the Portrait of the 6th Duke of Norfolk

Black chalk, heightened with white, on brownish paper, 37·6 × 23·6 (14 $\frac{13}{16}$ × 9 $\frac{5}{16}$)

Provenance: in the artist's sale (Lugt, 2092); T. Hudson (Lugt, 2432); Prince W. Argoutinsky-Dolgoroukoff (Lugt, 2602d); F. Koenigs (Lugt, 1023a); presented to the Museum by D. G. van Beuningen, 1940.

A study for the very late portrait, signed and dated 1677, of the 6th Duke of Norfolk (no. 53).

Boymans-van Beuningen Museum, Rotterdam

65 Studies of Arms and Hands

Black and red chalk, heightened with white, on brown paper, 38·1 × 26·7 (15 × 10 $\frac{1}{2}$)

Provenance: in the artist's sale (Lugt, 2092); T. Hudson (Lugt, 2432); Marignane (Lugt, 1872); bought by the Ashmolean Museum, 1937.

Literature: Woodward, p. 50 (no. 42).

A study for the hands of two of the sitters in the set of *Beauties* painted for the Duke and Duchess of York, *c.* 1662–5. The hand lower left is for the Duchess of Richmond, the other two are for the Countess of Falmouth and Dorset (O. Millar, *The Tudor, Stuart and Early Georgian Pictures in the Collection of H.M.*

Mr. Gibson [i.e. no. 18] told me Vandyke would take a little piece of blue paper upon a board before him, & look upon the Life & draw his figures & postures all in Suden lines, as angles with black Chalk & heighten with white Chalk' (B.M., Add. MS 22,950, f.15). There are many precedents in Van Dyck's English period for such preparatory drawings (H. Vey, *Die Zeichnungen Anton van Dycks*, Brussels 1962, pls. 251–93). The addition of oil paint in no. 62, perhaps to indicate the principal colour, or to modify what had at first been drawn in chalk, is unusual.

In no. 62 the figure is in a pose used by Lely for a number of patrons in the early 1660s. The drawing is probably the preparatory study for the figure of Lord Cornbury in the double portrait in the Clarendon collection (Beckett, no. 122) painted in 1661; and the pattern is used in reverse for such sitters as Lord Chesterfield (Melbourne Hall) and an unknown man, called a portrait of the artist (Kingston Lacy).

In the course of painting a portrait Lely would also make a study of drapery to assist in completing the figure. In August 1674, after he had 'dead-coloured' his portrait of Charles Beale, he 'took a drawing upon paper after an Indian gown which he had put on his back, in order to the finishing of the drapery of it'. It is interesting to note that some of the preparatory studies shown here (nos. 62–65) were all in Lely's possession at his death.

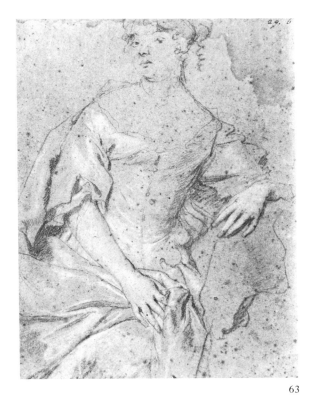

63

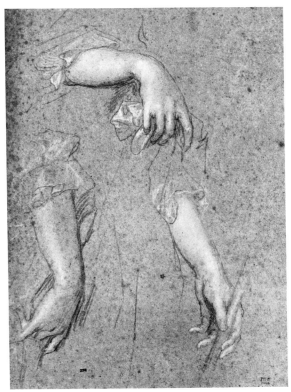

65

The Queen, 1963, nos. 258 and 259). Such studies, drawn from the life, could have been used by assistants in the studio in laying out and painting the final canvas, and thereafter; but in fact the hands in all but one of the *Beauties* can be attributed to Lely himself.

The Visitors of the Ashmolean Museum, Oxford

66 Study of an Arm and Hand

Black and red chalk, heightened with white, on buff paper, $19 \cdot 5 \times 26 \cdot 9$ ($7\frac{11}{16} \times 10\frac{5}{8}$)

Literature: Hand-List of the Drawings in the Witt Collection, 1956, p. 119 (no. 1012); J. Douglas Stewart, *Sir Godfrey Kneller*, National Portrait Gallery, 1971, no. 30.

Formerly attributed to Wissing, no. 66 is in fact a study for the right arm of the portrait of the Countess of Rochester in the set of *Beauties* (O. Millar, op. cit. no. 262). In function and style, however, it is exceptionally close to – indeed, well-nigh indistinguishable from – a drawing by Wissing in the same collection (no. 949) (J. D. Stewart, op. cit. no. 31).

Courtauld Institute of Art: Witt Collection

67 Study of an Arm and Drapery

Black chalk, heightened with white, on buff paper, $38 \cdot 6 \times 26$ ($15\frac{3}{16} \times 10\frac{1}{4}$)

Provenance: in the artist's sale (Lugt, 2092); T. Hudson (Lugt, 2432).

Literature: Hand-List of the Drawings in the Witt Collection, 1956, p. 32 (no. 851).

A study for the left side of the figure for the portrait of the Countess of Rochester, of which no. 66 is a study for one of the hands.

Courtauld Institute of Art: Witt Collection

68 Study of Hands

Black chalk, heightened with white, on buff paper, $27 \cdot 3 \times 23 \cdot 8$ ($10\frac{3}{4} \times 9\frac{3}{8}$)

Provenance: in the artist's sale (Lugt, 2092); T. Hudson (Lugt, 2432).

Literature: Hand-List of the Drawings in the Witt Collection, 1956, p. 32 (no. 849).

A study for the hands in a female portrait, *c.* 1665–70, called, probably wrongly, the Duchess of Cleveland, of which a version was at Avington Park.

Courtauld Institute of Art: Witt Collection

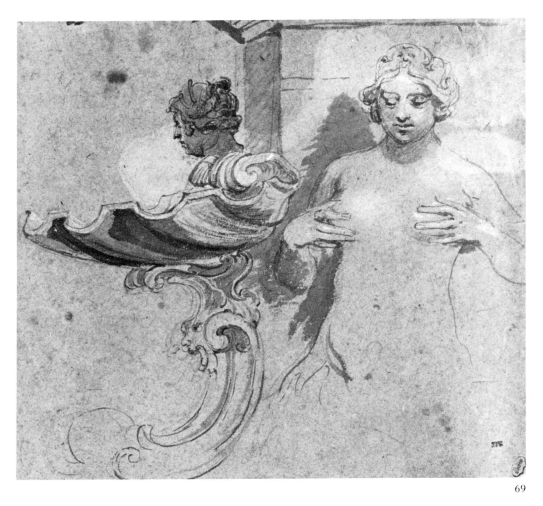

69

69 Study of details from the Diana Fountain

Grey wash over red chalk, heightened with white, on
brown paper, 24·8 × 26·4 (9¾ × 10⅜)

Provenance: T. Hudson (Lugt, 2432); H. S. Reitlinger,
sold Sotheby's 27 January 1954 (244), as by
Vanderbank.

Literature: J. Harris, 'The Diana Fountain at Hampton
Court', *Burl. Mag.*, CXI, 1969, pp. 444–8.

The Diana Fountain had been designed by Francesco
Fanelli for Charles I and set up in the Privy Garden at
Hampton Court. It was drastically altered in the time of
William III and finally re-erected in the reign of Queen
Anne in the basin in the great avenue in Bushey Park.

No. 69 is an example of a drawing being made by
Lely, or perhaps by an assistant, from a well-known
piece of near-contemporary baroque sculpture for use
as an accessory in a design. The sculpture appears in
the background of a portrait of the Duchess of Orléans
at Goodwood (*c.* 1662; Beckett, no. 402), and in a
variant of the design for Lady Lovelace, but most
clearly in a full-length of the Duchess of Cleveland at
Goodwood (*c.* 1670).

The drawing shows something of the original
design of the fountain, with the scallop shells on their
elaborate brackets level with the breasts of the bronze
sirens astride dolphins.

Private collection

70 Portrait of the Artist

(*Frontispiece*)
Black chalk, heightened with white, on brown paper,
38·7 × 31·4 (15¼ × 12⅜)
Signed and dated: *P Lely:fe: on: H* (initials in
monogram; the lost word at the end may have been
Himself).

Provenance: passed by descent, with drawings of the
painter's wife and their son John, in the artist's family
(Vertue, *Notebooks*, I, p. 143, and II, p. 7).

Literature: Woodward, p. 50 (no. 38); R.A., *British
Portraits*, 1956–7 (555); P. Hulton 'Sir Peter Lely:
Portrait Drawings of his Family', *Connoisseur*, CLIV,
1963, pp. 166–70.

Probably drawn in the early 1650s and the most
important surviving early likeness of the painter (for

whom see also perhaps nos. 11 and 14); an earlier drawing, which may be a self-portrait, was exhibited at Bristol in 1952 (no. 29, lent by Major-General Sir Neil Malcolm).

No. 70 is also one of Lely's earliest portrait-drawings. He produced during his career a number of such drawings – nos. 70 to 82 in the exhibition constitute a considerable part of those that survive – which are normally signed and were conceived as independent works of art. They are not related to commissioned portraits on canvas. No other portrait-painter in England had worked so copiously in this manner, in black and white or coloured chalks (the colour in general restricted to the face) and the technique was taken up and developed by Lely's followers (notably Greenhill and Tilson) and young contemporaries (see Croft-Murray and Hulton, pp. XXXIII–IV). Lely's technique and materials in *des portraits, qu'il a faits avec du pastel* greatly interested Christian Huygens in 1663, and were described by him in detail (C. Eisler, 'Apparatus and Grandeur', *Master Drawings*, VI, no. 2, New York 1968, pp. 148–55). Such drawings – 'Craions' – as were in Lely's studio at his death were in ebony frames. In the late 1670s drawings by Charles Beale were framed in ebony frames made by Mr Godbolt.

Private collection

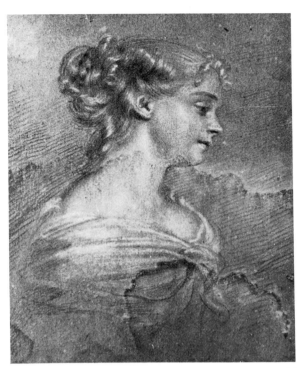

71

71 Portrait of a Girl

Black chalk, heightened with white, on brown paper, 25·4 × 20·3 (10 × 8)

Provenance: recorded among works of art in the possession of Sir Francis Child in his house in Lincoln's Inn Fields in 1699 (H.M.C., *8th Report*, part 1, 1881, p. 100b); thence by descent.

The three crayons listed in Sir Francis Child's inventory are among the earliest such records of a small collection of Lely's portrait-drawings. None of them is of an identified sitter (no. 71 appears as 'A woman's head in profile, by Sir Peter Lilly'). Among the crayons sold at Lely's sale was one of 'Mrs *Gratiana*'. No. 71 was probably drawn in the 1650s and is almost certainly of the girl used as the model for Europa in the painting at Chatsworth (Beckett, no. 582) and perhaps for the girl in the *Music Lesson* of 1654 (no. 24). Conceivably the sitter is identical with the Gratiana whose singing and dancing were celebrated in verses by Lovelace.

The Earl of Jersey

72 Portrait of a Young Man

Black and red chalk on brown paper, 22·9 × 18·1 (9 × 7⅛)

Signed: *P Lely* (initials in monogram)

Provenance: acquired by the Fitzwilliam Museum from the Aldeburgh Gallery, 1960.

Probably drawn in the early 1650s.

The Syndics of the Fitzwilliam Museum, Cambridge

73 Portrait of a Girl

Black and red chalk, heightened with white, on brown paper, 27·9 × 17·1 (11 × 6¾)

Signed: *P Lely* (initials in monogram)

Provenance: Sir Joshua Reynolds (Lugt, 2364); Thomas Poynder.

Literature: Woodward, p. 50 (no. 39); R.A., *British Portraits*, 1956–7 (550).

Probably drawn in the late 1650s. The sitter bears a close resemblance to Elizabeth Seymour, Countess of Ailesbury (1655–97), in a threequarter-length of her in oils (at Longleat) by Lely.

Private collection

74 Portrait of a Woman

Black and red chalk, heightened with white, on brown paper, 26·7 × 19·7 (10½ × 7¾)

Signed and dated: *P L 1658* (initials in monogram)

Provenance: Bellingham Smith.

Literature: Woodward, p. 52 (no. 50).

The sitter bears a slight resemblance to Elizabeth, Countess of Carnarvon (see no. 27); 'Several Heads of the Lady *Carnarvon*' were among the 'Craions' in Lely's sale, one of which was sold to Gibson and others for £2.13s.

Rijksmuseum, Amsterdam

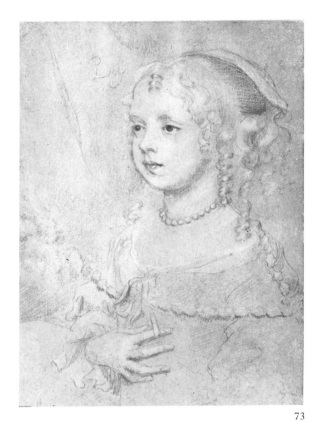

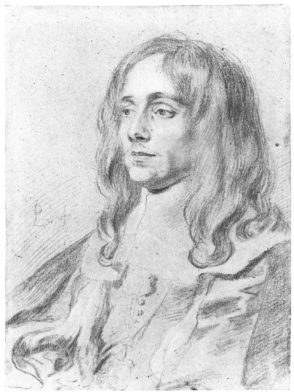

73

75

74A Portrait of a Woman

Black and white chalk, with touches of red chalk, on grey paper, 23·9 × 19·6 (9¾ × 7¾)
Signed and dated: *P Lely / 1658* (initials in monogram)

Literature: J. Pierpont Morgan Collection of Drawings, formed by C. Fairfax Murray, 1912, III, pl. 201.

Pierpont Morgan Library, New York

75 Sir Charles Cotterell (1615–1702)

Black and red chalk, heightened with white, on brown-grey paper, 27·7 × 19·4 (10⅞ × 7⅝)
Signed and dated: *P L fe* (initials in monogram)

Provenance: Sir Andrew Fountaine, sold Christie's 10 July 1884 (832), bought by the British Museum.

Literature: Croft-Murray and Hulton, p. 420 (no. 28).

The sitter, who had been a devoted royalist in the Civil War and friend and patron of William Dobson at Oxford, had been in the Low Countries in the Interregnum and in touch with Lely and Hugh May, chiefly in connection with the sale of the Duke of Buckingham's collections in Antwerp. He had been Master of

the Ceremonies to Charles I and was reinstated at the Restoration. In Lely's drawing he wears the gold chain and medal of office with which he was invested by the king on 22 April 1661. For a copy, see C. Eisler, 'Apparatus and Grandeur', *Master Drawings*, VI, New York 1968, p. 151.

In drawings such as nos. 74 and 75 Lely comes nearest in feeling to Samuel Cooper.

The Trustees of the British Museum

76 Portrait of a Woman

Black, red and white chalk on grey-brown paper, 24·4 × 18·4 (9⅝ × 7¼)
Signed: *P Lely* (initials in monogram)

Provenance: Spencer (Lugt, 1530); Esdaile (Lugt, 2617), sold Christie's 25 June 1840 (1264); Wellesley sale, Sotheby's 30 June 1866 (863).

Literature: Woodward, p. 50 (no. 41); Croft-Murray and Hulton, p. 419 (no. 24).

Probably drawn *c.* 1660.

The Trustees of the British Museum

77 Portrait of a Woman

Black, red and white chalk on grey-brown paper, 23·5 × 17·8 (9¼ × 7)
Signed: *P Lely* (initials in monogram)

Provenance: Wellesley sale, Sotheby's 30 June 1866 (851).

Literature: Woodward, p. 50 (no. 40); Croft-Murray and Hulton, p. 418 (no. 22).

Probably drawn *c.* 1660.

The Trustees of the British Museum

78 Portrait of a Woman as a Shepherdess

Black, white and red chalk on buff paper, 25·4 × 19·1 (10 × 7½)
Signed: *P Lely* (initials in monogram)

Provenance: F. C. Lewis; Rev R. Finch.

Literature: Woodward, p. 51 (no. 45).

Drawn in the early 1660s. The prototype for the Arcadian convention – the wide-brimmed hat of light material and the shepherdess's crook or *houlette* – was probably the portrait by Van Dyck of the Countess of Sunderland (Waller's Sacharissa), of which the most important versions are at Penshurst and Althorp. In Lely's day the most influential use of the convention was made by Huysmans in his portrait of the queen which Pepys saw in Huysmans's studio in August 1664 ('. . . drawne in one like a shepherdess'). This in turn probably influenced William Sherwin's engraving (1670) of the Duchess of Cleveland in the same Arcadian dress and with the *houlette* over her shoulder.

The Visitors of the Ashmolean Museum, Oxford

79 Portrait of a Woman

Black (in two shades), brown and red chalk, heightened with white, on buff paper, 26·5 × 19·1 (10⅜ × 7½)
Signed with the monogram *PL*. There are also possibly faint traces of a date; over the sitter's left shoulder is a flourish which is superficially like a second monogram.

Literature: L. van Puyvelde, *The Dutch Drawings . . . at Windsor Castle*, 1944, no. 610.

Drawn in the early 1660s. Among the 'Craions' in Lely's sale was a portrait of 'the late Lady *Chesterfield*' and it is conceivable that no. 79 is a portrait of the sitter in no. 34.

Her Majesty The Queen

80 Portrait of a Woman

Black, brown, red, a little pink(?) and yellow(?) chalk, heightened with white, on buff paper, 25·1 × 19·7 (9⅞ × 7¾)
Signed: *P Lely* (initials in monogram)

Provenance: recorded in the collection of George IV (no. 294 in the Carlton House inventory of 1819) as a portrait of Nell Gwyn.

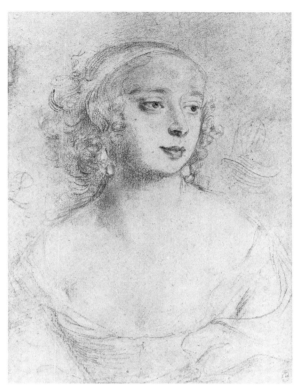

79

Literature: L. van Puyvelde, op. cit. no. 609.

Probably drawn *c.* 1665–70. The traces of colour suggest that such drawings may originally have been considerably richer in colour and texture. There are also in no. 80 traces of rock or drapery in the left background.

Her Majesty The Queen

81 Portrait of a Woman

Black and red chalk, heightened with white, on brown paper, 27·3 × 19·4 (10¾ × 7⅝)
Signed: *P Lely* (initials in monogram). There are also traces(?) of a date, below the signature, which may once have read *1667*.

Provenance: Thomas Poynder.

Traditionally described as a portrait of Sarah Jennings, Duchess of Marlborough. However, she was born in 1660 and the drawing almost certainly dates from the 1660s.

Private collection

82 John Greenhill (c. 1640/5–76)

Black, red and white chalk on grey paper, 27·3 × 20 (10¾ × 7⅞)
Inscribed, slightly later, with the identity of the sitter.

Provenance: Jonathan Richardson the Younger (Lugt, 2170); Sir J. C. Robinson, who presented it to the British Museum, 1857.

Literature: Croft-Murray and Hulton, pp. 417–18 (no. 20).

Probably drawn in the early 1660s, when the young man was working in Lely's studio. He was influenced by Lely's technique in portrait-drawing; and his *Self-portrait* (Croft-Murray and Hulton, pp. 339–40 (no. 1)) is technically very close to Lely and, as a likeness, tends to support the identification of no. 82 with Greenhill.

The Trustees of the British Museum

83 John Lely (d. 1728)

Black chalk, 13·1 × 12·4 (5⅛ × 4⅞)
Signed: *P Lely fecit* (initials in monogram) and inscribed by the artist: *Mr John Lely*

Provenance (with no. 84): Hugh Howard; Robert Howard, Bishop of Elphin; 5th Earl of Wicklow, from whom bought by the British Museum, 1874.

Literature: Croft-Murray and Hulton, pp. 419–20 (no. 26).

Drawn, with no. 84, towards the end of the artist's life. John Lely was a minor at the time of his father's death. His upbringing was the responsibility of his guardian, his father's executor Roger North, who at first placed him in the household of his brother, Lord Guildford: 'but some of his bad language and habits, picked up among his poor acquaintance, made him unfit to be continued there'. A course of travel turned him into a tiresome fop; and he married, while still a minor, a daughter of Sir John Knatchbull. It was from a second marriage that members of the family today are descended.

The Trustees of the British Museum

84 Anne Lely

Black chalk, 12·7 × 12·1 (5 × 4¾)
Signed: *P Lely fecit* (initials in monogram) and inscribed by the artist: *Mis Lely*

Provenance: see no. 83.

Literature: Croft-Murray and Hulton, p. 420 (no. 27).

A minor at the time of her father's death, when she was taken into the house of a niece of Hugh May. She married while still very young, in 1693, a Mr Frowd, but died in childbed of her first child.

The Trustees of the British Museum

85 Portrait of a Man

Black chalk, heightened with white, on buff paper, 18·2 × 16·8 (7⅛ × 6⅝)
Inscribed later: *D. Lauderdale*

Provenance: as for nos. 83 and 84.

Literature: Croft-Murray and Hulton, p. 419 (no. 25).

Although inscribed as a portrait of the Duke of Lauderdale, no. 85 does not bear a completely convincing likeness to him (i.e. in no. 37). It is, however, strikingly close to the head in a threequarter-length portrait of which two good versions are known: at Berkeley Castle as Sir William Berkeley (which is not possible) and, at Christie's 29 March 1963 (108), as Lord Fitzhardinge. It is probable that no. 85 is a drawing after, and not preparatory to, a painted portrait; and it may have been made in Lely's studio by an assistant.

The Trustees of the British Museum

Figures from the Procession of the Order of the Garter

Supporters of Charles I, and of the exiled Charles II, were admitted to the Order of the Garter during the Civil Wars and the Interregnum, but the great annual ceremonies, held to commemorate the Feast of St George, had not been held since the king had left Whitehall on the eve of the war. After the Restoration the College and Chapter of the Order were revived and the ceremonies henceforth carried out with full splendour. The dress of the Knights was, moreover, redesigned: with a festive form of dress, perhaps modelled on the ceremonial costume worn by the French king's Knights of the St Esprit, under the traditional mantle. Much more elaborate than the garments worn under the mantle in the time of Charles I, which were fundamentally everyday garments but made of very grand materials, this costume survived into the twentieth century. Edward VII was painted in it, as was the young Prince of Wales before the First World War; and it was worn by the four Knights who supported the canopy over Queen Elizabeth II at her Coronation. An example of the complete robes, worn by the Duke of Wellington, can be seen in Apsley House.

It is significant that whereas full-length portraits on the scale of life of Knights of the Garter in their robes are rare before the Restoration – there is a handful from the late Elizabethan and Jacobean period and only one by Van Dyck – Lely and the assistants in his studio produced a large number, many in sets, of the restored king, his brothers and their principal – or more extravagant – companions in the Order (see, for instance, nos. 43 and 52). At some point in the mid-1660s Lely made the famous series of drawings of figures in what is almost certainly intended to be the most solemn and illustrious part of the ceremony on 23 April: 'the *Grand Procession* of this Noble *Order*'. All the surviving drawings are described or discussed in this catalogue.

There is no contemporary reference to the drawings being made or to a specific commission to Lely with which they could be associated. The drawings themselves give so life-like an impression of figures moving down a processional route that they must have been drawn, or at least planned, while Lely was watching a ceremony or had such an occasion fresh in his mind. They are confidently drawn, with very few amendments. With their convincing sense of weight and movement and the play of shadow and reflected light in the draperies, they are the most powerfully baroque drawings ever produced in England: fundamentally Dutch in quality and with nothing of the nervous touch and ethereal quality of drawings by Van Dyck. It is not possible to fix the ceremonies which Lely could have observed. Evelyn described a Garter procession on 23 April 1667 (*Diary*, ed. E. S. de Beer, 1955, III, pp. 479–80), which went 'about the Courts of Whitehall'; a procession held in 1671 was almost certainly later than the cortège set out by Lely, but Hollar's plate illustrating the ceremony, published on pp. 576–7 of Elias Ashmole's *Institution, Laws & Ceremonies of the most Noble Order of the Garter* (1672), is a useful, if rather pedestrian, guide to the ceremonial and dress which Lely illustrates with more panache.

Lely's figures move down from right to left in the eyes of a spectator watching the procession. The humbler figures, the Poor Knights and the Canons, walk in pairs, but talk as they go or exchange a word or glance with a friend in the crowd. The Heralds chat to each other. The knights, all drawn singly, are more casual and seem to accost friends, turn to speak to a companion walking behind or beg him to take precedence. The conversational note throughout the procession is conspicuous. There is no evidence that the drawings were done in preparation for a larger work, indeed the finished quality of the drawings may make this unlikely. On the other hand Lely owned Van Dyck's oil sketch which had been painted for Charles I, probably in 1638, of the king and the Knights of the Order 'going a processioning upon St George's Day' which was the only surviving evidence of a scheme alleged to have been put forward for the decoration of a '*gran salone*' at Whitehall with scenes from the history and ceremonial of the Order (the sketch is reproduced and discussed in *The Age of Charles I*, Tate Gallery, 1972, no. 85). Charles I had been 'the greatest Increaser of the Honour and Renown of this most Illustrious Order'. Lely had been compelled to cede at the Restoration such works of art as had belonged to the king's father; but Van Dyck's sketch was in his collection at his death, although we do not know when it came into his possession. It is not inconceivable that Charles II gave it to him. Van Dyck's sketch is a beautiful evanescent synthesis of Anglo-Flemish baroque and the Venetian High Renaissance, but the postures of the Knights, although more rhythmical and flowing, are not unrelated to the stance of Lely's Knights, so much more worldly and solidly drawn. Both Van Dyck and Lely would have known the engraving of 1576 by Marcus Gheeraerts of the Garter procession, in which the Heralds, Pursuivants and Poor Knights walk in pairs (A. M. Hind, *Engraving in England in the Sixteenth & Seventeenth Centuries*, part I, 1952, pp. 107–21, pls. 52–58). A decorative cycle based on Van Dyck's designs would probably have been carried out at Whitehall; but it was at Windsor that the glorification of the Garter provided motives for so much of the decoration carried out for Charles II under the direction of Lely's friend Hugh May.

So large a collection of Lely's surviving drawings of the procession has not been assembled before, and it is sad that nos. 98 and 104 should have been withheld from what would otherwise have been a complete showing. The drawings are all apparently in the same technique and on the same paper, though certain sheets have obviously been trimmed and two (nos. 112 and 113) may have been cut or amended. A group of the drawings had belonged to Charles Jervas. On the twentieth day of his sale, beginning 24 March 1740, lot 1666 was '8 of the poor Knights of Windsor, in Caracatura, S. P. Lely'. An album containing sixteen drawings for the series was in an anonymous sale organised by De Leth in Amsterdam on 23 March 1763 and following days. From a comparison of the inscriptions on the drawings it should be possible to show that some had been together at an early date. Two (nos. 95 and 115), for example, bear near-contemporary inscriptions in English; a number (nos. 98, 101, 109 and 110) bear inscriptions of a later date in Dutch; and two (nos. 89 and 112) bear early Dutch inscriptions in a different hand (M. Benisovich, 'Two Drawings by Peter Lely', *Burl. Mag.*, XCI, 1949, pp. 79–80; R.A., *Charles II* (505); Croft-Murray and Hulton, pp. 409–16; Sir A. Wagner, *Heralds of England*, 1967, pp. 281, 283, 285, 287, 289, 291; British Museum, *British Heraldry*, 1978, nos. 92 and 241).

86 Two Poor Knights

Black chalk, heightened with white, on blue-grey paper, 49.1×35 ($19\frac{5}{16} \times 13\frac{13}{16}$)

Provenance: probably anon. sale in Amsterdam, De Leth, 23 March 1763 (16); Northwick sale, Sotheby's 6 July 1921 (146); Paul J. Sachs; bequest of Meta and Paul Sachs, 1965 (186).

Literature: M. Benisovich, 'Two Drawings by Peter Lely', *Burl. Mag.*, XCI, 1949, pp. 79–80.

In his Statutes of Institution of the Order of the Garter (1349) Edward III had decreed that twenty-six veteran warriors in needy circumstances should be established in the Chapel or College of St George, and that they were to wear a red cloak with one shield bearing the cross of the Saint but without an encircling Garter. Variously referred to as Alms-Knights or Poor Knights, they were the predecessors of the present Military Knights. They were constituted by the founder as a brotherhood of laymen to pray for the souls of the founder, his successors on the throne and the Knights Companion of the Order. For long periods the number of Poor Knights fell below strength. During

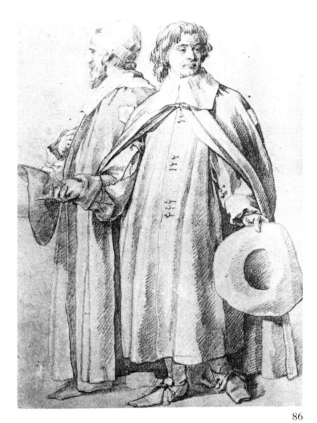

the Civil War the Poor Knights were in considerable distress, but during the Protectorate their numbers were raised by filling the establishment with supporters of Cromwell, some of whom were replaced at the Restoration (see E. H. Fellowes, *The Military Knights of Windsor, 1352–1944*, 1944).

Of the Poor Knights drawn by Lely, only one, Captain Richard Vaughan, can be identified. Those admitted on patents from the restored Charles II were veterans who had served his father with honour and distinction in the Civil War.

Fogg Art Museum, Harvard University, Cambridge, Massachusetts (Bequest of Meta and Paul J. Sachs)

87 Two Poor Knights

Black oiled chalk, heightened with white, on blue-grey paper, $53 \times 38 \cdot 1$ ($20\frac{7}{8} \times 15$)

Provenance: John Thane (Lugt, 1545); Henry Graves, from whom bought by the British Museum, 1862.

Literature: Croft-Murray and Hulton, p. 414 (no. 10).

The Trustees of the British Museum

88 A blind Poor Knight

Black oiled chalk, heightened with white, on blue-grey paper, $45 \cdot 1 \times 33 \cdot 7$ ($17\frac{3}{4} \times 13\frac{1}{4}$)

Provenance: anon. sale in Amsterdam, De Leth, 23 March 1763 (17); Dirk Versteegh sale, Amsterdam, 2nd part, 3 November 1823 (9(?)); Baron J. G. Verstolk de Soelen sale, Amsterdam, 22 March 1847 (332); bought by the British Museum.

Literature: Croft-Murray and Hulton, pp. 414–15 (no. 12).

The subject is almost certainly Captain Richard Vaughan, admitted as a Poor Knight on 28 July 1663 (he died, at the age of eighty, in 1700) in consideration of 'great sufferings in his means and hurts in his body'. He had lost his sight in the service of the king.

The Trustees of the British Museum

89 Two Poor Knights

Black oiled chalk, heightened with white, on blue-grey paper, 54×35 ($21\frac{1}{4} \times 13\frac{7}{8}$)

Inscribed at an early date on a separate slip of paper: *arme/Ridders Almes Knights/de mantel violet den rock* and, on the verso, *Sophia Sir P Lilly*

Provenance: anon. sale in Amsterdam, De Leth, 23 March 1763 (25(?)); bought by the British Museum from Dr Johannes Jantzen, 1955.

Literature: Croft-Murray and Hulton, p. 416 (no. 16).

The Trustees of the British Museum

90 Two Poor Knights

Black oiled chalk, heightened with white, on blue-grey paper, $54 \times 39 \cdot 7$ ($21\frac{1}{4} \times 15\frac{5}{8}$)

Inscribed later: *Poor Knights*

Provenance: as for no. 87.

Literature: Croft-Murray and Hulton, p. 414 (no. 8).

The Trustees of the British Museum

91 Two Poor Knights

Black oiled chalk, heightened with white, on blue-grey paper, $51 \cdot 4 \times 37 \cdot 8$ ($20\frac{1}{4} \times 14\frac{7}{8}$)

Inscribed later: *Poor Knights*

Provenance: as for no. 87.

Literature: Croft-Murray and Hulton, p. 414 (no. 9).

The Trustees of the British Museum

92 Two Poor Knights

Black oiled chalk, heightened with white, on blue-grey paper, $49 \cdot 5 \times 37 \cdot 5$ ($19\frac{1}{2} \times 14\frac{3}{4}$)

Inscribed later: *Poor Knights*

Provenance: as for no. 87.

Literature: Croft-Murray and Hulton, p. 414 (no. 11).

No satisfactory explanation has been put forward for the marked change in scale of the figure on the right.

The Trustees of the British Museum

93 Two Canons

Black oiled chalk, heightened with white, on blue-grey paper, 52·7 × 38·3 (20¾ × 15⅛)
Inscribed later: *Cannons of the Order*

Provenance: as for no. 87.

Literature: Croft-Murray and Hulton, p. 413 (no. 4).

A College of Canons serving the Chapel had been an integral part of the original Chapter, their number raised to twelve early in its history. The Dean and Canons had been expelled by the forces of Parliament in 1643; and some very distinguished men were included among those appointed by Charles II after the Restoration. In Lely's series, drawings survive of all twelve Canons. Among occupants of the twelve stalls at that time were: Thomas Browne (1605–73), who had been Domestic Chaplain to Archbishop Laud and to Charles I; John Lloyd, a Chaplain to the king in exile; William Brough, formerly Dean of Gloucester and Chaplain to Charles I; Peter Mews (1619–1706), who had borne arms for the king in the Civil War, fought against Monmouth at Sedgemoor and was successively Dean of Rochester, Bishop of Bath and Wells and Bishop of Winchester; John Durell, who in 1677 was appointed Dean; George Evans (1630–1702), a distinguished antiquary; and Ralph Brideoake (d. 1678), who became Dean of Salisbury and Bishop of Chichester (see S. L. Ollard, *The Deans and Canons of Windsor*, 1950).

The Trustees of the British Museum

94 Two Canons

Black oiled chalk, heightened with white, on blue-grey paper, 51·4 × 38·1 (20¼ × 15)
Inscribed later: *Cannons*

Provenance: as for no. 87.

Literature: Croft-Murray and Hulton, p. 413 (no. 6).

The Trustees of the British Museum

95 Two Canons

Black oiled chalk, heightened with white, on blue-grey paper, 53·3 × 37·8 (21 × 14⅞)
Inscribed, probably in a contemporary hand: *The Prebends of Windsor in blacke . . . an*

Provenance: as for no. 87.

Literature: Croft-Murray and Hulton, pp. 413–14 (no. 7).

The Trustees of the British Museum

96 Two Canons

Black oiled chalk, heightened with white, on blue-grey paper, 52·1 × 37·8 (20½ × 14⅞)
Inscribed later: *Cannons of the Order*

Provenance: as for no. 87.

Literature: Croft-Murray and Hulton, p. 413 (no. 4).

The Trustees of the British Museum

97 Two Canons

Black chalk, heightened with white, on blue-grey paper, 48·6 × 41·4 (19⅛ × 16 5/16)

Provenance: anon. sale in Amsterdam, De Leth, 23 March 1763 (20) bought J. van der Marck; Rudolf Weigel, Leipzig, before 1836.

Literature: M. Benisovich, 'Two drawings by Peter Lely', *Burl. Mag.*, XCI, 1949, pp. 79–80.

E. B. Crocker Art Gallery, Sacramento, California

98 Two Canons (not exhibited)

Black chalk, heightened with white, on blue-grey paper, 49 × 36 (19 5/16 × 14 3/16)
Inscribed later: *Arme Ridders*

Provenance: Jullien (?), Academy of Fine Arts, St Petersburg; came to the Hermitage (no. 14712), 1924.

Literature: M. Dobroklonsky, *Catalogue of Flemish Drawings in the XVIIth–XVIIIth Centuries*, Leningrad 1955, p. 73 (no. 274), text in Russian.

Hermitage Museum, Leningrad

99 A Pursuivant

Black chalk, heightened with white, on blue-grey paper, 46·7 × 26·2 (18⅜ × 10 5/16)

Provenance: H. de Kat sale, 4 March 1867 and following days (156); J. de Clercq (d. 1867); families de Clercq and Van Eeghen.

Literature: J. Q. van Regteren Altena, *Verzameling Mr Chr. P. van Eeghen*, Museum Fodor, Amsterdam 1935, no. 61; *Dutch Genre Drawings of the Seventeenth Century*, New York, Boston, Chicago 1972–3, no. 60.

The Pursuivants can be distinguished from the Heralds because they wear their tabards athwart. The four Pursuivants in 1665 were Robert Chaloner (succeeded two years later by Robert Hornebroke), Thomas Holford, Henry Dethick and Francis Sandford.

Private collection, Netherlands

100 A Pursuivant

Black oiled chalk, heightened with white, on blue paper, 49·8 × 20·4 (19⅝ × 8 1/16)
There are traces of an inscription; also inscribed later: *P Lely f*

Provenance: Ploos van Amstel (Lugt, 3002); J. de Vos Jacsz. (Lugt, 1450); sold Amsterdam, 22 May 1883 (291).

Literature: E. W. Moes, *Oude Teekeningen na de Hollandsche en Vlaamsche School in het Rijksprentenkabinet te Amsterdam*, I, The Hague n.d., no. 50.

Rijksmuseum, Amsterdam

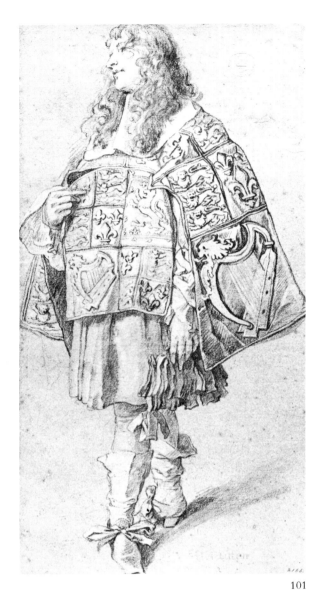

101

101 A Pursuivant

Black chalk, heightened with white, on blue-grey
paper, 49·5 × 25·1 (19½ × 9⅞)
Inscribed: *Herauten*

Provenance: acquired by the Museum, 1861.

Victoria and Albert Museum

102 Two Heralds

Black and white chalk on blue-grey paper, 51·8 × 37·9
(20¾ × 14¹⁵⁄₁₆)

Provenance: bought by Sir Robert Witt from Colnaghi,
1935.

Literature: Hand-List of the Drawings in the Witt

Collection, 1956, p. 32 (no. 1259); often exhibited, e.g.
Courtauld Institute Galleries, 1958, no. 6; R.A.,
Charles II (512).

It has been suggested that the sitters might be Thomas
St George and John Wingfield who were respectively
Somerset Herald and York Herald.

Courtauld Institute of Art: Witt Collection

103 Two Heralds

Black chalk, heightened with white, on blue-grey
paper, 52·1 × 28 (20½ × 11¹⁄₁₆)
Inscribed: *Herauten*

Provenance: M. van Fries (Lugt, 2903).

Literature: O. Benesch, *Meisterzeichnungen der
Albertina*, Salzburg 1964, p. 357 (no. 153), for earlier
bibliography.

It has been suggested that the figures in this, the most
famous and probably the most distinguished of the
series, are Henry St George, Richmond Herald, and
Thomas Lee, Chester Herald.
 A third drawing of two Heralds from Lely's series,
formerly in the Kupferstichkabinett in Berlin (no.
12807), is presumed to have been lost in the Second
World War (catalogue by Friedländer-Bock-Rosenberg,
1930, p. 127, measurements given as 52·4 × 38·5). One
of the Heralds there was almost certainly Elias Ash-
mole, Windsor Herald, the other possibly William
Ryley, Lancaster Herald.

Graphische Sammlung Albertina, Vienna

104 A Knight of the Garter (not exhibited)

Black chalk, heightened with white, on blue-grey
paper, 66 × 33·5 (26 × 13³⁄₁₆)

Provenance: Kobenzl collection; came to the Hermitage
(no. 5926), 1768.

Literature: M. Dobroklonsky, *Catalogue of Flemish
Drawings in the XVIIth–XVIIIth Centuries*, Leningrad
1955, pp. 72–3 (no. 273), text in Russian.

It is not easy to identify with conviction the Knights of
the Order of whom drawings survive in Lely's series;
but no. 104 can confidently be identified as Charles
Stuart, 4th Duke of Richmond and Lennox (1639–71),
who had been created a Knight in 1661. The features in
the drawing accord well with those in the full-length in
Garter robes by Lely, now in the North Carolina
Museum of Art (no. 96 in the *Catalogue* of 1956,
reproduced).
 It should be noted that in certain drawings of the
Knights Lely omits the collar which is always worn
with the robes of the order or, when it is included,
sometimes leaves out the ribbons by which it is fastened
to the mantle.

Hermitage Museum, Leningrad

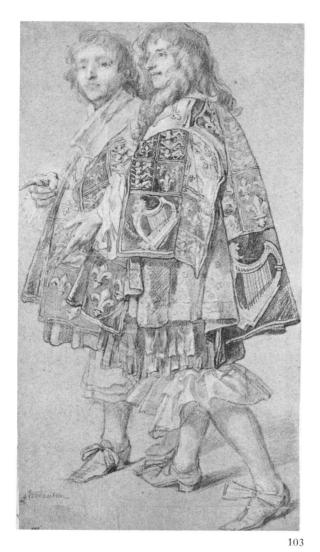

103

105 A Knight of the Garter

Black chalk, heightened with white, on blue-grey paper, 51·4 × 30·5 (20¼ × 12)

Provenance: probably anon. sale in Amsterdam, De Leth, 23 March 1763; Versteegh, 1823; Westenberg; de Visser.

Literature: D. Hannema in *Oude Tekeningen uit de Verzameling Victor de Stuers*, Almelo 1961, no. 93.

The sitter bears a resemblance to Aubrey de Vere, 20th Earl of Oxford (1626–1703), created a Knight in 1661.

Collection V. de S., Netherlands

106 A Knight of the Garter

Black chalk, heightened with white, on blue-grey paper, 47·9 × 37·3 (18⅞ × 14¹¹⁄₁₆)

Provenance: Earl of Warwick sale, Christie's 20 May 1896 (212).

Literature: R.A., *Drawings by Old Masters*, 1953, (436).

The gestures and attitudes of the Knights are conspicuously more varied and histrionic than those of the less important figures who had preceded them in the procession.

The Devonshire Collection, Chatsworth: The Trustees of the Chatsworth Settlement

107 A Knight of the Garter

Black oiled chalk and red chalk, heightened with white, on blue-grey paper 50·7 × 30 (20 × 11⅞)
Inscribed later: *de Cancelier der Ordre van/de Kouseband met een/violet fluweele Mantel* and *P:Lely, f.*

Provenance: J. de Vos Jacsz. (Lugt, 1450); sold Amsterdam, 22 May 1883 (291).

The edge of the mantle, which could not be fitted into the limits of the sheet, is drawn separately.

Rijksmuseum, Amsterdam

108 A Knight of the Garter

Black oiled chalk, heightened with white, on blue-grey paper, 49·8 × 32·4 (19⅝ × 12¾)

Provenance: G. Morant sale, Christie's 21 April 1847 (990), bought by the British Museum.

Literature: Croft-Murray and Hulton, p. 415 (no. 13).

The sitter bears a slight resemblance to James Butler, 1st Duke of Ormonde (1610–88), who had been created a Knight in 1649.

The Trustees of the British Museum

109 A Knight of the Garter

Black oiled chalk, heightened with white, on blue-grey paper, 48·9 × 27·9 (19¼ × 11)
Inscribed later: *de Koning*

Provenance: John, Lord Northwick; Capt E. Spencer-Churchill sale, Sotheby's 5 July 1921 (146); F. Lugt (Lugt, 1028), acquired 1921; Fondation Custodia (no. 747).

Literature: Dutch Genre Drawings of the Seventeenth Century, New York, Boston, Chicago 1972–3, no. 59; *Hollandse Genre-Tekeningen*, Rijksmuseum, Amsterdam 1973, no. 59.

Although inscribed as a drawing of Charles II as Sovereign of the Order, the sitter does not bear any resemblance to the king (see, for example, no. 52); and it could be assumed that walking in the procession, under the Sovereign's canopy, the king would walk with a more formal step, rather as he does in Lely's standing full-length Garter type portrait in oil.

Fondation Custodia (Coll F. Lugt), Institut Néerlandais, Paris

110 A Knight of the Garter

Black chalk, heightened with white, on blue-grey
paper, 44·3 × 33·7 (17$\frac{7}{16}$ × 13$\frac{1}{4}$)
Inscribed later: *een Ridder*

Provenance: H. Oppenheimer sale, Christie's 10–14
July 1936, (457); C. P. van Eeghen.

Literature: De Verzameling van Mr Chr. P. van Eeghen,
Amsterdam 1958, no. 51.

Private collection, Netherlands

111 A Knight of the Garter

Black oiled chalk, heightened with white, on blue-grey
paper, 49·8 × 32·4 (19$\frac{5}{8}$ × 12$\frac{3}{4}$)

Provenance: as for no. 108.

Literature: Croft-Murray and Hulton, p. 415 (no. 14).

The sitter bears some resemblance to James, Duke of
York (see nos. 32 and 41), who had been a Knight of
the Garter since 1642.

The Trustees of the British Museum

112 The Usher of the Black Rod and the Dean of Windsor, Register of the Order

Black oiled chalk, heightened with white, on blue-grey
paper; on two conjoined sheets, 45·7 × 39 (18 × 15$\frac{3}{8}$)
Inscribed: *King of Armes met een/satijne mantel* and
root/Decken van Windsor Registermeest[er]

Provenance: D. Versteegh sale, Amsterdam, 2nd part,
3 November 1823 (9); Baron J. G. Verstolk de Soelen
sale, Amsterdam, 22 March 1847 (332), bought by the
British Museum.

The Usher of the Black Rod was Sir Edward de
Carteret (d. 1683). He carries his sceptre of office, but
the inscription erroneously describes him as a King of
Arms. The fragmentary state of the drawing (no. 113)
which is of Garter King of Arms, and the fact that this
sheet has been made up, may indicate a confusion in
identity in the early history of the series. In the proces-
sion, Black Rod and Garter would normally walk side
by side.

Since September 1660 the Dean had been the ardent
royalist Bruno Ryves (1596–1677). A Chaplain to
Charles I, he had been deprived of his benefices in
1642. In a sermon delivered in 1662 he ascribed various
disasters to the reprieve granted to some of the
regicides.

The Trustees of the British Museum

113 Garter King of Arms

Black chalk, heightened with white, on blue-grey
paper, the figure cut out down the left and the left side
of the sheet subsequently made good, 52·3 × 32·2
(20$\frac{5}{8}$ × 12$\frac{11}{16}$)

Provenance: acquired by Sir Robert Witt.

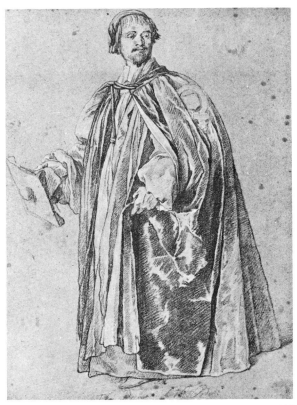

115

*Literature: Hand-List of the Drawings in the Witt
Collection,* 1956, p. 32 (no. 3012).

Sir Edward Walker (1612–77) had been created Garter
on 25 March 1645, when he was in attendance on
Charles I as secretary at war of the Privy Council. He
followed the king into exile. After the Restoration he
was on bad terms with his fellow Heralds.

Courtauld Institute of Art: Witt Collection

114 The Chancellor of the Order of the Garter

Black chalk, heightened with white, on blue-grey
paper, 49·2 × 31·9 (19$\frac{3}{8}$ × 12$\frac{9}{16}$)

Provenance: Sutherland collection (Burnet, II, p. 722).

Sir Henry de Vic (*c.* 1599–1671), for nearly twenty
years English Resident in Brussels in the service of
Charles I, was with Charles II in exile and at the
Restoration was created Chancellor of the Order. A
second version, thought to be a double offset, is in the
British Museum (Croft-Murray and Hulton, pp. 415–
16 (no. 15).

The Visitors of the Ashmolean Museum, Oxford

115 The Prelate of the Order

Black oiled chalk, heightened with white, on blue-grey paper, 50·3 × 35 (19⅞ × 13⅞)
Inscribed: *The Prelate of the Order*

Provenance: John Thane (Lugt, 1545); Henry Graves, from whom bought by the British Museum, 1862.

Literature: Croft-Murray and Hulton, pp. 412–13 (no. 3).

George Morley (1597–1684) had been a member of Lord Falkland's circle and a friend to Edmund Waller. He went into exile in France and the Low Countries. At the Restoration he became successively Dean of Christ Church, Bishop of Worcester and, in 1662, Bishop of Winchester and Prelate of the Order. A prominent member of the Restoration episcopate, Morley was described by Clarendon as 'of very eminent parts in all polite learning; of great wit, and readiness, and subtilty in disputation . . . most grateful in all the best company'.

The Trustees of the British Museum

116 A Canopy-Bearer

Black oiled chalk, heightened with white, on blue paper, 49·8 × 23·5 (19⅝ × 9¼)

Provenance: anon. sale in Amsterdam, De Leth, 23 March 1763 (24 or 28); J. van der Marck sale, Amsterdam, 29 November 1773 (1439); D. Versteegh sale, Amsterdam, 2nd part, 3 November 1823 (9(?)); Baron J. G. Verstolk de Soelen sale, Amsterdam, 22 March 1847 (332), bought by the British Museum.

Literature: Croft-Murray and Hulton, pp. 411–12 (no. 1).

The four corners of the canopy borne over the Sovereign in the procession were supported by Gentlemen of the Privy Chamber.

The Trustees of the British Museum

Index

Named sitters (paintings and drawings)

Beaufort, Mary Capel, Duchess of, and her sister Elizabeth, Countess of Carnarvon 27

Catherine of Braganza, Queen 38

Charles I with James, Duke of York 6

Charles I, The Children of 7

Charles II 52

Chesterfield, Elizabeth Butler, Countess of 34

Cleveland, Barbara Villiers, Duchess of 45

Clifford of Chudleigh, Thomas, 1st Baron 42

Cotterell, Sir Charles 75 (drawing)

Cotton Family, The 30

Cromwell, Oliver 22

Dorset and Pembroke, Lady Anne Clifford, Countess of 4

Dysart, Elizabeth Murray, Countess of 23

Dysart, Lionel Tollemache, 3rd Earl of 58

Gibson, Richard, and his Wife 18

Greenhill, John 82 (drawing)

Grosvenor, Sir Thomas 57

Harman, Sir John 40

Henchman, Humphrey, Bishop of London 39

Holles, Sir Frescheville, and Sir Robert Holmes 48

Isham, Sir Thomas 56

James II when Duke of York 32, 41

James II when Duke of York, with Charles I 6

Lauderdale, John Maitland, Duke of 37

Lely, Anne 84 (drawing)

Lely, John 83 (drawing)

Lely, Sir Peter 29, 70 (drawing)

Lely, Sir Peter, with Hugh May 51

Lichfield, Lady Charlotte Fitzroy, Countess of 47

Massey, Sir Edward 10

May, Hugh, with Sir Peter Lely 51

Newdegate, Sir Richard 55

Norfolk, Henry Howard, 6th Duke of 53, 64 (drawing)

Norfolk, Jane Bickerton, Duchess of 54

North, Roger 59

Nottingham, Heneage Finch, 1st Earl of 50

Oxford, Diana Kirke, Countess of 46

Pelham, Lady Lucy 9

Perryer Family, The 26

Pett, Peter 17

Portsmouth, Louise de Kéroualle, Duchess of 49

Romney, Henry Sidney, Earl of 19

Rothes, John Leslie, 7th Earl and 1st Duke of 21

Rupert, Prince 43

Southampton, Thomas Wriothesley, 4th Earl of, with his 3rd Wife, Lady Frances Seymour 31

Temple, Sir William 36

York, Anne Hyde, Duchess of 33

Other subjects (paintings)

Concert, The 11

Girl playing a Theorbo-Lute, A 13

Infant Bacchus, The 15

Man playing an eleven-course Lute, A 14

Man playing a Violin, A 12

Music Lesson, The 24

Portrait of a Boy 28

Portrait of a Girl 1

Portrait of a Girl: 'The Little Girl in Green' 20

Portrait of a Lady 3

Portrait of a Lady and Child as Venus and Cupid 44

Portrait of a Man 2, 5

Portrait of a Young Man 8, 35

Sleeping Dwarf, A 16

Sleeping Nymphs by a Fountain 25

Drawings

Landscapes 60–1

Working drawings 62–9

Portrait heads 70–85

Garter procession 86–116